鯤

TUNG LUNG HSU

許東榮作品集

鯤

許 TUNG
東 LUNG
榮 HSU

「北冥有魚，其名為鯤。鯤之大，不知其幾千里也。化而為鳥，其名為鵬。鵬之背，不知其幾千里也；怒而飛，其翼若垂天之雲。是鳥也，海運則將徙於南冥。南冥者，天池也」

-- 庄子 逍遙遊

莊子在「逍遙遊」中，描述了一種極大的魚，名為「鯤」，因為對於天空的幻想而轉變為一隻翱翔空中的大鳥，名為鵬。大魚經由脫落的皮膚而長出羽毛，怒而飛向天空，這是生命對原有格局的突破，如同藝術家許東榮的創作，由繪畫演變至雕塑再走回繪畫，在兩種創作形式中切換，展現了他由內而外衝破個人邊界的努力，以及對個人在藝術裡恣意翱翔的渴求。

目錄
Contents

扶搖而直上：許東榮 2019 個展創作脈絡解析

胡懿勳

　　「鯤」是許東榮 2019 年個展的主題。從他的自述可以看出，這個題目似乎醞釀有很長一段歲月了；包含生活、創作、學習、思考種種的歷程與軌跡相互交融成為這次展覽的創作主題意識。

　　「鯤」的深遠寓意是莊子《逍遙遊》的精髓。其實，很難給予「鯤」一個確切的名狀，我並不打算重覆許東榮在創作自述中對於莊子的闡釋，畢竟他自己從創作實踐所體悟的一番道理，會更深刻和貼近自我。然而，我們無法回避對「鯤」這難以名狀的思考，所以，將從許東榮自身創作的感受，以及站在旁觀者立場對他的創作進行評析，以這兩個面向探討許東榮 2019 年個展的主題，以及他的作品如何反應出「鯤」的哲學思想內涵；或者說，是許東榮自我的創作觀照。

由生活經歷建構的的創作自述

　　如果從解讀許東榮對於莊子思想的體悟角度入手，容易造成畫蛇添足的累贅。畢竟，許東榮是從幾十年的創作實踐和生活歷練裡堆疊自己的逍遙遊體悟，那種精神性的豐富並不是普通人可以辦到的。我大膽假設：這次展覽的新聞稿就是許東榮自己撰寫的創作自述；儘管是用第三人稱的筆調，依然要高度懷疑是他自己執筆或口述完成。我們便把這篇體悟完整地留給創作者自己吧。

　　我對「鯤」探討的興趣，在於許東榮的莊子哲學思想背後的支撐內容是什麼？如何從他的創作和生活中找出莊子的關聯。莊子思想並非只發生在創作，與許東榮的生活歷練是脫離不了關係的，或者說是緊密結合在一起的。

　　許東榮不定時在臉書網頁發表創作的心得，他曾歸納自己的作品形式轉變認為：「我的雕刻變化大概可分三階段：轉、扭、折，皆因不同的創作方式而改變……」 其後介紹〈三太子〉作品時也曾表示：「鑄鐵、銅、漢白玉不同材料造成不同效果，所

以，問我畫畫的（人）為什麼要去做雕刻？因為早期小學門前有五府乾歲的廟，我下課後常停留那裡看石匠和木匠做雕刻，深植腦海。那種三度空間及聳立而立體的感覺不是平面繪畫能表現出的效果，所以作品常有現在的造型，也會加入傳統民間故事，但是用現代符號來表達……」

1983 年 1 月阿波羅畫廊展出「許東榮現代玉雕展」，應該是有紀錄較早以玉石雕刻手法回應他開過玉雕工廠以及對玉石辨識、切割、雕琢的技術曾有扎實的認識；以貴重玉石為材料的雕刻持續到 1995 年，仍然有公開的展覽紀錄可查。從 1983 和 1992 年代的幾件玉雕作品，在於表現玉鏈環環相連，扣環巧動而曲折，傳承自傳統琢治鏈條需取材於造型本身，卻又要達到「取其材而不離其體」的巧藝。十餘年間，他將雕琢、碾磨技藝，加入石雕的刀法，在轉、扭為主的造型樣態中持續探討平面與空間交錯的意象。2011 年他在北京中國美術館展出的一件大型戶外石雕作品，最能體現石雕、玉雕表現技藝的結合，這件作品「內斂外張」的造型原理也最能呼應「內枝、外葉、鏤空」等技法的傳承意涵。

回溯許東榮的職場生涯，他因開設過民俗古玩店，對傳統民間廟宇雕刻技巧有自己的觀察和吸收，即如「內枝、外葉、鏤空、鋪面、圓邊、均勻」的技法，亦即淺浮雕（剔底）、深浮雕（內枝外葉）、透雕（鏤空）及圓雕（四面見光）等雕刻形式，幾乎在他的營生過程中完備。

如果說，現實生活是創作的來源或依據，那麼，許東榮的創作養分源自於現實生活的組成部分，主力並非全然是題材或主題意識的反應，其創作過程各種涉及材料、技法、工藝技術等方面的實踐經驗，也給予創作對材質和技術方面的深入挖掘。諸如，填充玩具的打樣、剪裁與縫製，化學藥劑的研發、調配，各種工具器材的運用，這些生活經歷都可以解決技術上為創作帶來的窒礙或困擾。換句話說，解決技術的問題，則可以在平面或立體創作表達中更加寬廣、不受技術侷限地轉化自身的理念和想法。

當生活經驗達到相當的厚實程度，同時又結合創作不斷地實踐和實驗各種的可能性。很自然地，在年歲的推進裡，思想觀念

也將隨之逐漸昇華至一種哲學的思考境界。在許東榮的觀念裡，哲學只是打開思維的學問，自己的抽象畫創作即是打開對繪畫固定思維的一種方式。

就他自己的創作軌跡與思維相互聯繫分析，較為確切的時間節點應該是 20 世紀末，許東榮開始繪畫與雕刻雙軌齊步並行，進入哲學思考探索的領域；這時候，他已經將近耳順之年。我相信，從這個年歲開始，他為自我思想做出一種提煉。又經歷十年之後，及至 2019 年的個展以「鯤」為名，顯示他在莊子思想找到一個相應的契合點，他也臻於從心所欲之年了。

旁觀許東榮的創作軌跡

去除一些台灣早期庶民生活的物資困窘，許東榮的童年生活中有一段關於初次接觸藝術時所帶給他很愉快的回憶；在他日後學習、創作時，工匠們製作廟裡神像的景象成為一種養分。

從這次的展覽作品大致看出許東榮創作歷程的三種軌跡，第一個可以視為呼應許東榮幼年時期台灣庶民生活中藝術元素給他的觸動，大多數是以漢白玉材質的雕刻形式呈現；第二條軌跡是許東榮自我創作觀照的體悟，從雕塑和繪畫兩領域進行交叉實踐；還有一條軌跡隱含（游移）在這兩條軌跡之間，可以說是兩條軌跡的中間交界地帶，也是許東榮這批作品中最能顯現他個人哲學思想的脈絡。

我們先從比較容易解讀的第一條脈絡談起吧。這條受到台灣民間藝術滋養，清晰可見的脈絡陸續有十年以上，時不時就出現在許東榮的雕塑創作中。舉凡民間廟宇裡供奉的神明、仙佛、尊者乃至於祂們的衣裝或者手勢、姿態都是許東榮取材的參照。然而，許東榮透過石材雕刻的手法，將這些神佛轉化為一種較為純粹的視覺意象，我們看到的石雕作品很容易從腦海中的生活記憶裡，搜尋出對廟裡神佛的印象。這種伴隨著思想與信仰，在台灣民間有極強普遍性的欣賞過程，恰好反映出台灣本土的生命動力。

姑且先用「化繁為簡」來形容他在創作時提取民間雕刻意象

的手法；可是又不能那樣簡單歸納，只是化繁複為簡煉的過程而已；其中有更多值得推敲的內容需要說明。我們觀賞諸如〈三太子〉、〈觀音〉、〈飛天〉、〈關公〉這類有明顯主題指涉的作品，可以從一個主視角的石雕態勢看到這些神祇、天神或仙人隱約出現在眼前。但是，若我們開始移動身體，牽引自己的視角在作品上下左右觀看時，我們會發現原先可以辨識的神仙姿態，漸漸解構成一個純粹的立體造型。此時，觀賞者正經歷一段由聯想轉化為直觀造型變換的審美過程；這其中「時間的位移」成為作品與觀賞者互動的關鍵要素。

第二條脈絡應該是從許東榮完成台師大美術教育之後開始啓動的。我分析的側重點則從 2000 年之後，因為在這將近二十年的時間裡，許東榮的繪畫和雕刻才真正達到同步前進的態勢。如同他自己的描述一般，「哲學只是打開思維的學問」，他在兩種創作中開始了思想的提煉，他的抽象畫創作試圖打開對繪畫固定思維的一種方式。

2019 年的中秋節，許東榮畫了一張五彩繽紛的抽象畫 (高 130cm 寬 192cm)，他說：「這一陣子，為了做雕刻，都是單色，就很衝動想換一些有色彩的畫面，有一名人說：畫抽象畫，高潮迭起，處處都有讓你意想不到的驚奇，不像傳統繪畫開始就知道結果。」如同嘗試以各種非傳統工具創造繪畫效果般，他再次強調：「最重要的一點就是不必遵守傳統繪畫的章法和工具。」對他來說，長久以來熟練的傳統繪畫的固定程序是一種思維的侷限；意即，他視「有形」為制約因素，也是可觀可及的突破口，由此進入探求「無形」的境地。因此，觀賞許東榮的作品必須把平面和立體兩種作品放在相同的視野對照，我們會發現，他的立體空間雕鑿和平面繪畫的筆調往往有互補的作用。

第三種脈絡融合著自我創作觀照和生活取材兩種內涵，主要側重在借由創作形式的探討，展現自我的創作思想 (考)，這條脈絡在他某些平面繪畫和立體雕刻兩類作品中，出現相互貫穿和融會的現象。如果換個角度分析，他將一種創作意識在平面和立體作品中游移，試圖在表現形式中達成多維度的探索；就創作的時間軸觀察，往往也會出現間歇性的迂迴和延續狀態。這種情況

十分值得玩味，我們似乎察覺到許東榮的思考可以持續很長的時間，他試圖解決某個不確定因素時，這類的創作就會持續一段往復的時間。

大象無形與逍遙遊的共伴

　　在作結論之前，我想進一步直接從作品的分析回應上述的軌跡（脈絡），以便於說明許東榮在創作上的迂迴與延續。我對自己在 2014 年 7 月針對許東榮抽象繪畫所撰寫的評論內容依然具有信心，當年在《無圖之畫：許東榮》(PAINTING WITHOUT FIGURE) 運用視覺心理學的觀察方法，從作品的視覺形式入手探索作者創作意圖和心理狀態，自有其源自藝術原理的根據。本文不再贅述已經分析過的抽象畫內涵和美學觀點，重心則放在立體作品的梳理。

　　當 2011 年〈水袖〉、〈舞動〉兩件作品出現時，似乎就預示即將會有一系列探討面積在空間中扭轉的作品陸續出現，2014 年作〈飛天〉先回應「大相無形」系列的抽象理念，其後 2014 年作〈大士〉，2015 年作〈觀自在〉到 2017 年的〈自在蓮花〉，2018 年〈天女散花〉又回溯〈水袖〉的造型意念升發。

　　類似的情況在 2012 年以半具象作〈一葦渡江〉、〈尊者〉（竹葉青石材）兩件作品之後，2013 年以不同材質重作的〈尊者〉，而 2015 年作的〈醉俠〉以及 2016 年作〈魁星〉到 2018 年的〈三太子〉又出現他試圖解決前期未完成的創作思考；或者說是對原生環境的反芻。若進一步分析，2019 年在上海油雕院展出的〈擁抱〉與〈翱翔〉石雕創作，應該算是分別在 2010 年與 2011 年就已經對莊子哲思醞釀的創作發想。〈擁抱〉的形式是沒有起訖端點的圓形循環，〈翱翔〉則是開放式上揚的造型意象，又直接呼應著 2019 年力作〈鵬〉。當然，〈鯤〉必須與〈鵬〉並列看待成許東榮的逍遙遊之作。

　　2013 年「大相無形」系列的展出，可謂是「逍遙遊」的楔子。許東榮創作的理念是：源於老子的思維，亦即順從天意的發揮並無固定的形體，「無形」的設想穿梭在抽象繪畫與立體雕刻之間，

並以藝術形態呈現。接續著 2015 年出版的圖錄中的繪畫作品，標誌著 2010 年的抽象繪畫正好對應同一年創作的雕刻作品，從半具象轉向全抽象的意味更加深遠。延續與迂迴在老莊之間的開放思維，2019 年的個展以「鯤」為題，即是在大象無形與逍遙遊穿梭的一段軌跡。

結論：逍遙遊裡的「鯤」

在台灣早期的學院教育環境里，藝術菁英幾乎集中在掌握美術教育的師範體系之中，如許東榮這輩的美術菁英進入大學美術系、藝專等院校成為培育後進的良師。相較之下，許東榮台師大美術系畢業之後的職涯經歷確實讓人感到意外地驚訝，他沒有從事人人羨慕的教職，反而跨入一場又一場事業的探險，卻也從未放棄創作的初心。

我大致歸納他的生活經歷有三個面向足以影響他對創作的觀照：其一，對自己原生環境的依戀；其二，直面生活歷程的提煉；其三，創作是反芻自己不同階段的思索。所以，擷取生活的意象轉換成藝術形式表現的初始階段，許東榮多數時間是篩釋生活經驗的現實性，進入審美領域探求創作的滿足。這個尚處創作衝動的時間段仍就「有形」之境變動作品的時間位移關係。從「有形」到大象無形的境地，許東榮的創作進入時空交錯的迴旋，他借由不知其幾千里的北冥之「鯤」將化為怒而飛，其翼若垂天之雲的「鵬」，蘊含自身對放開束縛的扶搖而直上之意。

在這篇解析文章即將要結束之時，我必須承認用文字解析許東榮作品的局限很大；也有可能是我自己的學識不足，以至於行文時會遭遇詞窮的窘境。然而，我更願意相信許東榮的雕刻作品必須要親臨現場與作品面對面，觀者方能體會到許東榮雕刻作品的細緻手法和他處理空間、面積、體量、材質肌理變化的奧妙之處。他的抽象繪畫的純粹度即與立體作品同樣體現出相同的特質。而我在運用文字上的窘困，恰巧反應許東榮這次展覽的主題「鯤」—幻化無形汲取天意的核心精神。我們更可以期待，許東榮接下來將要以何種哲思再度幻化出他的創作。

To Mount upon a Great Wind
-- Context Analysis of Tung Lung Hsu's 2019 Solo Exhibition

By Hu Yixun

"Kun" is the theme of Tung Lung Hsu's 2019 solo exhibition. As we can see in his self-portrait essay, he has been pondering on that topic for a while. In this exhibition, his life experience, his career as a student as well as an artist, and his personal thoughts and reflections on art have all intertwined with one another and eventually blended into the subject.

"Kun" and its widely known metaphor is of the essence of Chuang-tzu's "A Happy Excursion". It is hard to accurately describe Kun's appearance according to Chuang-tzu's writings, and I don't think it's necessary to repeat Tung Lung Hsu's interpretation of Chuang-tzu here in this article either. After all, it's his understanding based on his practice as an artist, which is also the reason why it is so insightful and close to the truth in the innermost being. Nevertheless, I can't stop thinking about the indefinable "Kun", so, based on his life experience, I try to read his artworks and unscramble the theme of his 2019 solo exhibition from a bystander's point of view, focusing on how his works reflectthe philosophical connotation of "Kun", or, how his art creation mirrors the his own inner world.

Self Narrative Built Upon Life Experience

It would be superfluous if we try to interpret Tung Lung Hsu from the perspective of his personal understanding of Chuang-tzu's philosophy. After all, behind all his thoughts and ideas on "A Happy Excursion", there is decades of rich life experience and practice as an artist, whichis hardly attainable by ordinary people. I highly suspect that the press release of this exhibition isactually a form of self narrative of Tung Lung Hsu written in third person by himself or at his dictation at least. So, let's leave his interpretation untouched.

My interest in "Kun" lies in the context, that is the supporting substance behind Tung Lung Hsu's understanding of Chuang-tzu's philosophy, and how to find the link between Chuang-tzu and Tung Lung Hsu's work & life. Besides the artworks that reflect Chuang-tzu's philosophy, I believe there's also a rather deep connection and entanglement between Chuang-tzu's philosophy and the artist's life experience.

Mr. Tung Lung Hsu shares thoughts about his work on Facebook from time to time. About the change of forms of his creativity, he wrote:"My sculpting has been through three stages: turning, twisting and folding, which changes with the methods I adopt..." Later, when introducing the "The Third Prince", he said: "Different materials, such as foundry iron, copper and white marble, produces different effect. Anyway, why do I, a painter, want to do sculptures? In my early years, in front of my elementary school there was a temple housed the "Five Thousand-year Gods". I use to spend rather long time there after school watching the stonemasons and carpenters make sculptures, and that scene has deeply etched into my memory ever since. Lofty statues standing towering in a three-dimensional space and that is not something painting could do justice. And that's why my sculptures look the way they are. Sometimes I would also use modern symbols to represent the elements of traditional Taiwan folk stories and integrate them with my sculptures…"

In January 1983, Apollo Gallery hosted the"Tung Lung Hsu Modern Jade Sculptures Exhibition", which probably was one of the earliest events on record that reflected the fact that he once ran a jade carving factory and had solid understanding of the technology of jade identification, cutting and carving. Open record shows that he kept using precious jade as sculpting materials until 1995. Several piece she made during 1983 to 1992 focused on showcasing the subtlety and complexity of jade chains and rings, and how they exquisitely contrived. In traditional Chinese jade carving, how a jade chain look usually depends on the natural shape of the material itself, which demands carvers to attain the skill of "carving the material without severing it from its main body". And Tung Lung Hsu spent over a decade exploring how to interlace two and three-dimensional spaces in sculpting. He combined the skillsof jade sculpting, grinding and stone carving together and created most of his "turning and twisting" sculptures during that period. In 2011, he had a large-scale outdoor stone carving piece exhibited in the National Art Museum of China in Beijing which probably was the best example of the combination of stone carving and jade carving techniques in his artworks. Besides, the "introverted on the inside and outstretched on the outside" concept embodied in this work also echoes the old techniques so-called" inner branch, outer leaf, hollowing out" of traditional jade carving that he tried to carry forward.

DuringTung Lung Hsu's scareer as an artist, the experience of owing and running a folkcraft and antique shop allowed him to observe and absorb traditional temple sculpture techniques such as "inner branch, outer leaf, hollowing out, paving, rounding edges and evening". When earning a living, he had also improved in various sculpting techniques and methods includingshallow relief (with the technique of flat plane engraving), deep-carving relief (with the technique of "inner branch, outer leaf")and circular engravure (visible from all sides).

If real life is the source or basis of art creation, Tung Lung Hsu gets his inspiration from the components of reality. In other words, the main effect of reality on his work does not entirely lies in the subject matters or his consciousness of them. His creation process involves all of hispractical experience in materials, techniques, crafts and other aspects, which eventually impels him continuously to explore deeper into materials and techniques. For example, proofing, tailoring and sewing stuffed toys, researching and mixing chemical agents, handling various tools and equipments, all these experiences of his in real life can be usedsolving technical obstacles during art creation. In other words, by unshackling the chain oftechnical problems, these experiences allow him expressing his ideas and thoughts more freely in broader space whether in flat surface or three-dimensional artworks.

When conducting experimental ideas and testing possibilities in his work, his life experience also reaches a rather substantial level of richness. Naturally, his views and values also have evolved into a philosophical level as he grows older. In his idea, philosophy should serve as a tool to open up the mind, just as he considers his abstract work a way tobreak out of established thinking pattern of painting.

Based on cross analysis of his art career and his ideological evolution over time, I think it was the end of the 20th century when Tung Lung Hsu started to paint and carve at the same time and entered the realm of

philosophy. He was nearly 60 years old at that time, and I believe it was at that point in time he started sort out his own thoughts and tried to conclude something. After another ten years, the 2019 solo exhibition named "Kun" shows that he has found a meeting point between Chuang-tzu and his own philosophy, and as an artist, he has also reached a stage where he can follow his bent at will in making art.

See the "Threads" From an Onlooker's Perspective

In spite of the material deprivation occurring among the lower class in Taiwan, Tung Lung Hsu had a very delightful memory of his first contact with art when he was a child. The scene of craftsmen making temple god statues has become a source of nutrients for his studying and art creation.

From all the works included in this exhibition, I see three "threads" in Tung Lung Hsu's whole art creation. The first thread features mostly white marble sculptures, which I believe is inspired by the folk art elements from his childhoodin Taiwan. The second thread embodies the artist's self-insight alternately in the forms of sculpture and painting. The third thread lurks and wanders on the boarder of the other two, which makes it probably the one that do full justice to the evolving path of Tung Lung Hsu's personal philosophy.

Let's start with the first thread that seems most clear and easier to read. Nurtured by Taiwanese folk art, this thread extends continuously more than ten years and appears in Tung Lung Hsu's sculptures from time to time. All the gods, Bodhisattvas and venerable idols enshrined and worshiped in folk religious temples, even their clothes and gestures have all become reference materials for Tung Lung Hsu.

With techniques of stone carving, Tung Lung Hsu transformed his memory of these deities into more straightforward, more visual images. However, the stone carving works we see in his exhibition can still easily stir up our memories of real temple statues. This kind of association triggered by values and beliefs is quite a common occurrence among the Taiwanese audience, which also proves the strong vitality of Taiwan folk art.

"Reducing complexity to simplicity" is one way to describe his technique of drawing materials from traditional folk carving images for his own creation, only it is not that simple. Besides the process of reducing complexity, there is more content worth pondering.

When appreciating his sculptures with obvious themes such as "The Third Prince", "Guan Yin", "Flying Apsaras" and "Guan Yu", we can usually see the images of their models, namely the namesake gods and immortals looming in front of us from a certain perspective. However, as we move along and look at them from top to bottom, left to right, these celestial images start to gradually fall apart and develop into something more simplified and three-dimensional. During that process, intuitiveand simple appreciation of the sculptures takes replace of the association of images and recalling of memories in our heads, and the "moving of time" becomes the key to trigger interaction between the sculptures and the viewers.

The second thread started right after Tung Lung Hsu finished his academic art training in Taiwan Normal University. However, I would like to focus on the time period from 2000 to now during which Tung Lung Hsu's painting and sculpting actually started to progress in pace. As he described in his own words, "Philosophy should serve as a tool to open up the mind", he started to refine his thoughts in two genres of artand use abstract painting as a way to break out offixed thinking pattern.

At the Mid-autumn Festival of 2019, he finished a colorful abstract painting (130cm in height and 192cm in width). He said: "For a long while I have been making single-colored sculptures, which urges me to make a change and return to colorful paintings. A famous people once said that unlike the creation of traditional paintings which you can see it through to the end from the beginning, the process of abstract painting is full of incessant surprises." He also likes to create different graphic effect with various non-traditional tools. As to that, he stressed, "The most important rule is not to stick to any rule or tool of traditional painting." For him, the fixed procedure of traditional painting, which has been familiar to us for a long time, only places restrictions on thinking. In his opinion, "tangibility" is a restrictive factor, but it could also be apossible breach and portal to higher level where "the great image has no shape" . Therefore, to better understand Tung Lung Hsu, we must put his plane and three-dimensional works in the same field of vision so that we can see the complementation between his three-dimensional carving and his painting brushstrokes.

The third thread integrates his self-reflection with subject matters from daily life. It has mainly focused on manifesting the artist's thoughts and reflections on art creation by exploring in different forms. This thread has run through and linked up many of his paintings and three-dimensional works. From another angle, he seemed to be trying to fit the same guiding ideology into both paintings and sculptures to achieve multi-dimensional exploration.On observation of the time axis, there are also intermittent detour and renewal in the threads of his creativity now and again, which I think is very worth pondering. I realize that when Tung Lung Hsu tries to identify an uncertainty factor during work, he intends to spend quite a long time reflecting on and exercising his creativity around that subject back and forth.

When "The Great Image Has No Form" Meets "A Happy Excursion"

Before coming to any conclusion, I would like to continue on the analysis of the afore-mentioned "threads" directly from the perspective of his works so as to better explain the detour and continuity of his creativity.I still feel confident in my previous comments on his abstract painting.In the article "Painting without figure: Tung Lung Hsu" I wrote in July 2014,I had already applied the observational method of visual psychology to explore his authorial intent and psychological state based on artistic principles and my visual perceptions on his works. So this article will not unnecessarily elaborate on the connotation and my standpoint at his abstract painting, but focus on his three-dimensional works.

"Water Sleeves" and "Dancing", two pieces of sculptures he finished in 2011, seem to be the prelude to a series

of works that discuss how flat surfaces move and twist in spaces. The piece "Flying Apsaras" he made in 2014 was the first corresponding to the abstract concept ofhis " The Great Image Has No Form" series.After that, "The Disciple of Buddha" in 2014, "Guan Yin" in 2015, "Guan Yin on Lotus" in 2017 and "The Heavenly Maids Scatter Blossoms" in 2018 were published successively, echoing and enriching the philosophical thinking heinjected in "Water Sleeves".

A similar situation to that occurred after the publication of two semi-concrete pieces, "Crossing the River on a Reed" and "The Venerable Monk" (in green bamboo leaf stone) in 2012. In 2013, he remade "The Venerable Monk" with different materials. After that, with the "Drunken Hero" in 2015, "Kui Xing" (the god of literature) in 2016 and "The Third Prince" in 2018, he once again tried to further explore a unfinished thinking from before and ruminated on the native environment where he grew up. Further analysis indicates that he started to brew thoughts on Chuang-tzu's philosophy as early as in 2010 and 2011 when he published the "Embrace" and "Soaring". Among the two pieces that exhibited in Shanghai Oil Painting Sculpture Institute in 2019, "Embrace" takes the form of a round circle with no beginning or end, while "Soaring" presents an open and upward image which directly echoes his 2019 masterpiece "Peng". And "Peng", as it should be, is regarded as a side-by-side piece to "Kun" and a part of the "A Happy Excursion" series.

The exhibition of "The Great Image Has No Form" series in 2013 can be seen as the prelude to the "A Happy Excursion" series. Tung Lung Hsu actually gets his ideas of this series from another Chinese philosopher Lao-tzu. According to Lao-tzu, he should go with natural, spontaneous instinct and abandon fixed forms in art. It appears the idea of "formlessness" has infiltrated into both his paintings and sculptures. The painting album he published in 2015 included the abstract paintings he made in 2010 when his transition from semi-concrete to full abstract got to a further point with both painting and sculpting. Meanwhile, he keeps his mind open to both Lao-tzu and Chuang-tzu. The 2019 solo exhibition titled with "Kun" could actually be seen as another thread that connects Lao-tzu's "The Great Image Has No Form" and Chuang-tzu's "A Happy Excursion".

Epilogue: The "Kun" in "A Happy Excursion"

In Taiwan's college education system of earlier days, almost all art elites gathered in normal institutes that had been dominating the art education of Taiwan. Many outstanding artists of Tung Lung Hsu's generation became teachers at art departments of universities or art training schools. By contrast, Tung Lung Hsu's career experience after he graduated from the art department of Taiwan Normal University was beyond anyone's expectation. Instead of taking a teaching position of everyone's envy, he has embarked on one adventure after another and always remains true to his original aspiration for art.

To sum up, there are three factors that have significantly influenced his self-insight and creativity: first, his attachment to the place he came from; second, his reflection on his own life experience; third, constant re-

examination of previous thoughts and ideas.

At the initial stage of his career when he took images from real life and reproduce them in the form of art, Tung Lung Hsu spent most of his time screening his own life experiences, trying to single out the part that meets the threshold of art and creativity. During this stage when he was driven by impulse on some level, most of his works still need to assume certain "tangible forms" in order to deliver varied presentations. After that, he explored further into the concept of "formlessness" and created a whirlwind of time and space in his works. The northern ocean fish "Kun" that is "thousand miles in size" and the "Peng" that "obscures the sky like clouds with its wings" both connotate the artist's wish to break every fetter and mount upon a great wind to the sky.

With this article coming to an end, I must admit that words have too many limitations in interpreting Tung Lung Hsu, or maybe I am just not well read enough to write an article that can do his works justice. However, I prefer to believe it's because we need some face-to-face time to really understand Tung Lung Hsu's sculptures and how he exquisitely handles the space, surfaces, and various material textures. And my inadequacy in wording actually accords with the core value connotated by the theme of the "Kun" exhibition, that is, "don't obsess with tangible forms, don't resist the will of nature". In the future, we expect to see more philosophic evolution in Tung Lung Hsu's creativity.

早期創作

Early Art Work

早期創作 *1980-1998*

1983 年，許東榮首次在阿波羅畫廊推出玉雕個展，而此也是他「鍊條系列」的首次發表，將中國古物中常見的鍊條造型，與現代造型的雕塑並置結合，展現出他希望透過自己的創作，建立一條介於中國古典文化與現代藝術間的橋梁；1987 年，許東榮受到大華中學的委託，創作大型的景觀雕塑〈日月乾坤〉，透過這個創作經驗，他開始注意到石材本身的特色以及作品與陳列環境的之間的關係，因此他暫時擱置了藝術中關於符號性的研究，而將注意力放在雕塑材質的原本面貌上——他利用了石材特有的透光度，把未經打磨的粗糙面和人工修飾過後的光滑面加以並置，強調雕塑在觸覺和視覺上的衝突性，對應出空間中虛實相生的依存關係；相隔三年，許東榮再度接受委託，於台北忠孝東路的金融中心製作四件景觀雕塑〈眾星拱月〉，這一次他運用的是不同石材的組合，在經過一連串現場的裝置和調整後，他成功地將墨綠色的加拿大玉和建築本身的黑色花崗岩融合，將雕塑粗糙與光滑的表面，與周邊環境整合為一體——這個系列，除了可以被視作是對前一階段材質性的跨越外，也是中國古典哲學中「師法自然」和「天人合一」等理念的初步實踐。

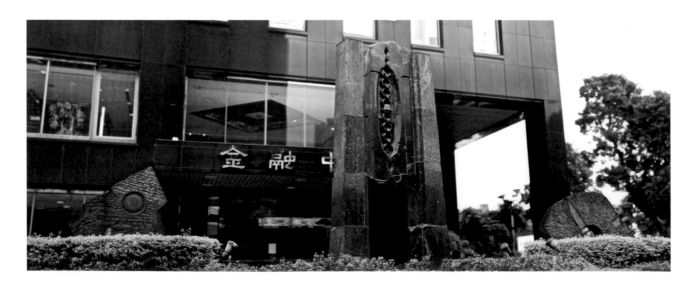

Early Art Work 1980-1998

Tung Lung Hsu launched his first solo exhibition of jade carvings in Apollo Gallery in 1983. It was also the first publication of his "Chains" series in which he integrated chains commonly seen in Chinese antiques and cultural relics into modern sculptures, hoping to forge a connection between Chinese classical culture and modern art. In 1987, Dahua Middle School commissioned Tung Lung Hsu to make a large-scale landscape sculpture "Sun, Moon, Heaven & Earth". During that experience, he began to pay attention to the characteristics of different stones and the relationship between artworks and their displaying environment. Therefore, he temporarily shelved his research on symbolism and started to focus on the original features of materials. Inspired by the light transmitting feature of stones, he starkly juxtaposed the unpolished rough side of a stone together with the artificially processed smooth side to emphasize the tactile and visual contrast which also reflected the interdependent relationship between the virtual and the real in space. Three years later, Tung Lung Hsu was commissioned again to make four landscape sculptures themed "A Myriad of Stars Surround the Moon" for the Financial Center located at Zhongxiao East Road in Taipei. This time, he used a combination of different stones. With some on-site installations and adjustments, he managed to pull together dark green Canadian jade and black granite of the building, and integrate the rough and smooth surfaces of the sculptures perfectly into the surrounding environment. This series could be regarded as a leap forward of the artist on materials, and a preliminary practice of the "learning from nature" and "unity of nature and man" in Chinese classical philosophy.

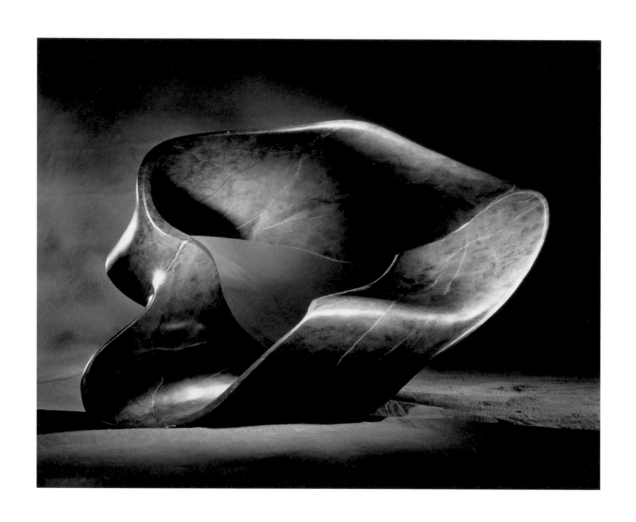

漂 *Floats* / 加拿大玉 *Canadian Jade* / *H57 x W75 x L28 cm 2003*

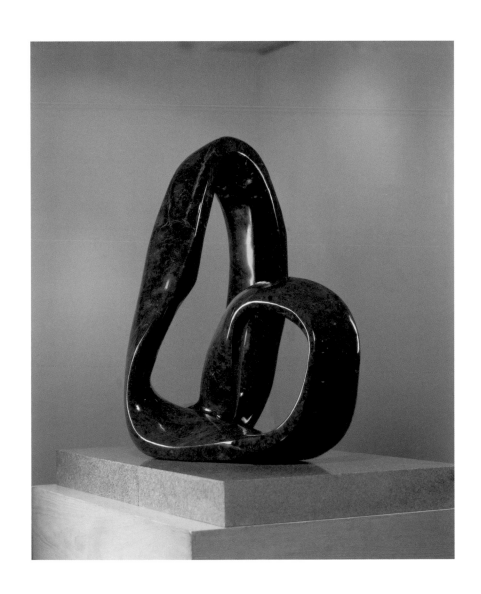

濤 *Big Waves* / 加拿大玉 *Canadian Jade* / *H88 x W47 x L49 cm 2004*

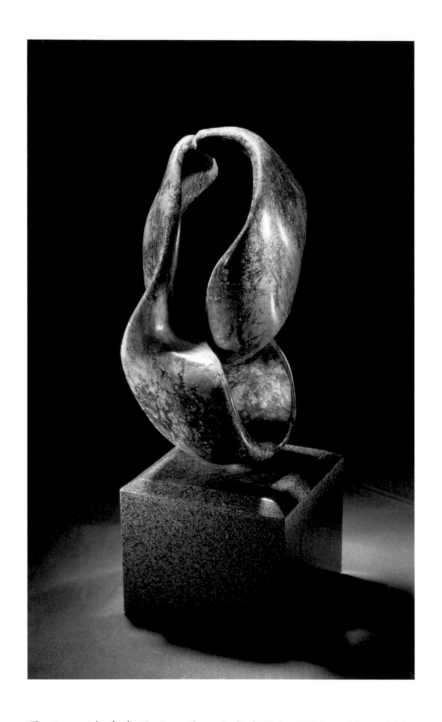

漂 *Floats* / 加拿大玉 *Canadian Jade* / *H50 x W27 x L19 cm 2005*

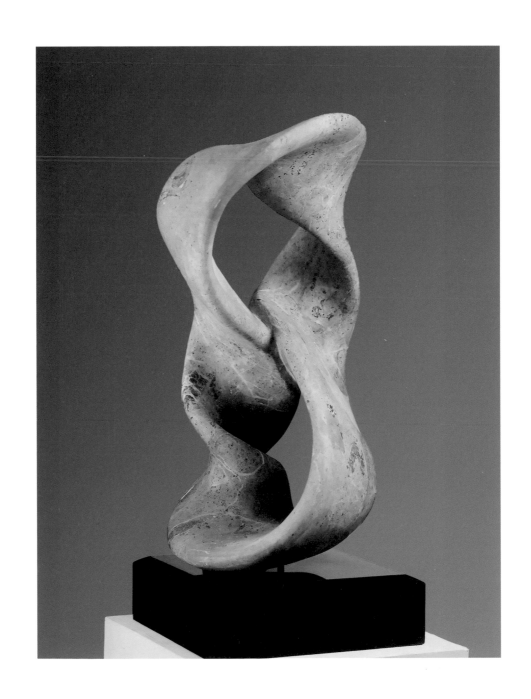

轉 *The Rotation* / 哈密翠 *Hami Jade* / *H55 x W26 x L23 cm 2005*

行雲流水系列

Flowing Clouds and Running Water Series

行雲流水系列 *1998-2009*

2009 年，許東榮受到威斯汀酒店之邀，製作 11 件預計陳列在酒店大廳的作品。在此，許東榮延續上一個階段對於中國古典哲學的思索，在作品中融入更多東方美學的元素，古典書法中線條表現的千變萬化 ---- 在線性的連續造型中，演繹出節奏、頓挫、圓潤、轉折等行雲流水的動勢。為了使造型語言本身更簡煉，他選用的是色澤潔白溫潤的漢白玉，將原本堅硬敦厚的玉石，轉化成在空間中悠然飄動的彩帶 ---- 輕盈、靈動、婉轉。中國書法中講究的筆走龍蛇，可說是讓許東榮從這一系列的作品中獲得了立體化的驗證。

正如許東榮自己所秉持的：「藝術來自生活，而創作也只是純粹地將概念和美學修養發表在作品上。」閱讀他的作品，對大多數的人來說並不困難，但細心的觀眾仍然可以從中找到自己所熟悉的感性線索和文化涵養中的吉光片羽。

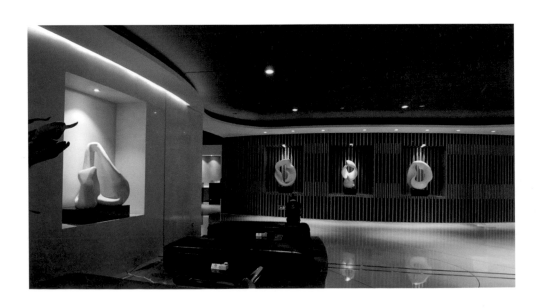

Flowing Clouds and Running Water 1998-2009

In 2009, Tung Lung Hsu was invited by Westin Hotel to make 11 sculptures expected to be displayed in the hotel hall. For this series, he continued his exploring into Chinese classical philosophy by infusing more elements of oriental aesthetics into his works. For instance, he introduced the ever-changing brushstrokes of Chinese calligraphy into his sculptures to create the rhythmic momentums, mellowness and fullness, rise and fall, twist and turn with linear shapes and forms. To simplify the language of the sculptures, he chose warm, spotless white marble as material, and turned the hard, solid jade into light, flexible, graceful and smoothly floating ribbons. Under Tung Lung Hsu' s hands, exquisite brushstrokes of Chinese calligraphy made a three-dimensional re-appearance in a series of sculptures.

Tung Lung Hsu believes that "Art comes from life, and art creation is just a way to publish concepts and aesthetic accomplishment". It's not very difficult for most people to read his works. However, only those who are attentive and sensitive can find the hidden clues and fragments to the emotional and cultural treasures.

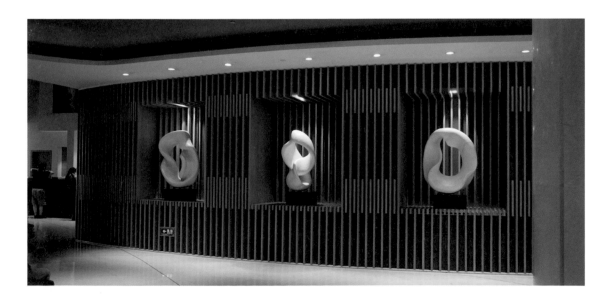

雲彩飛舞 *Clouds* / 漢白玉 *White Marble* / *H110 x W85 x L135 cm 2011*

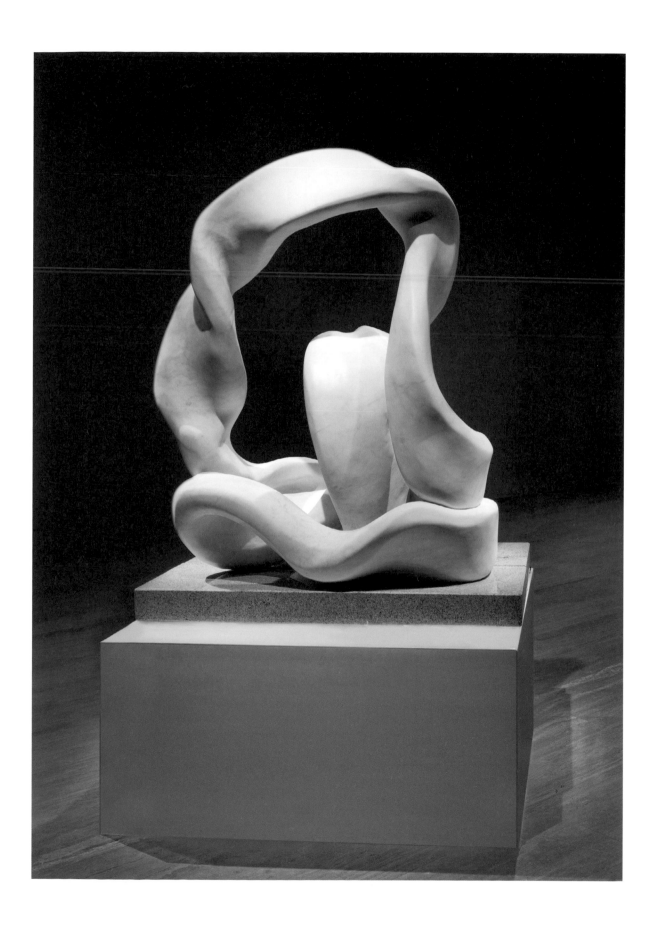

日月乾坤 *The Sun and Moon* / 黑花崗岩 *Black Granite* / *H80 x W90 x L75 cm 2011*

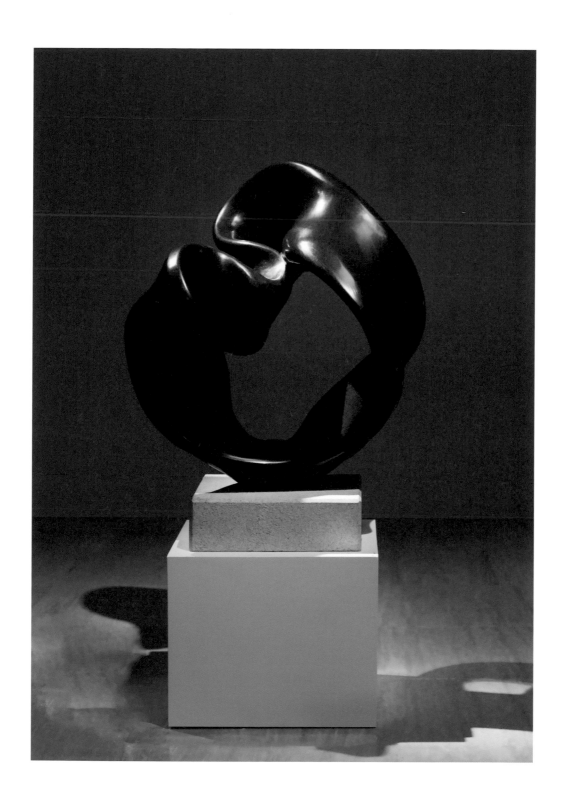

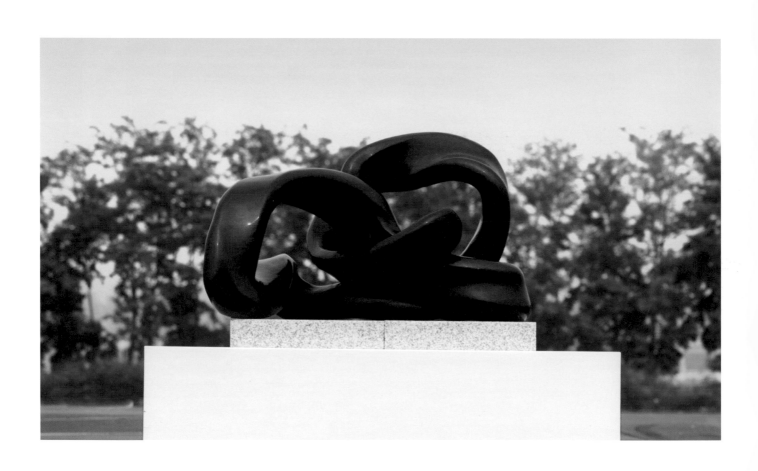

如意 *As One's Wish* / 黑花崗岩 *Black Granite* / *H127 x W80 x L73 cm 2011*

廣東美術館收藏 *Collected by Guangdong Museum of Art*

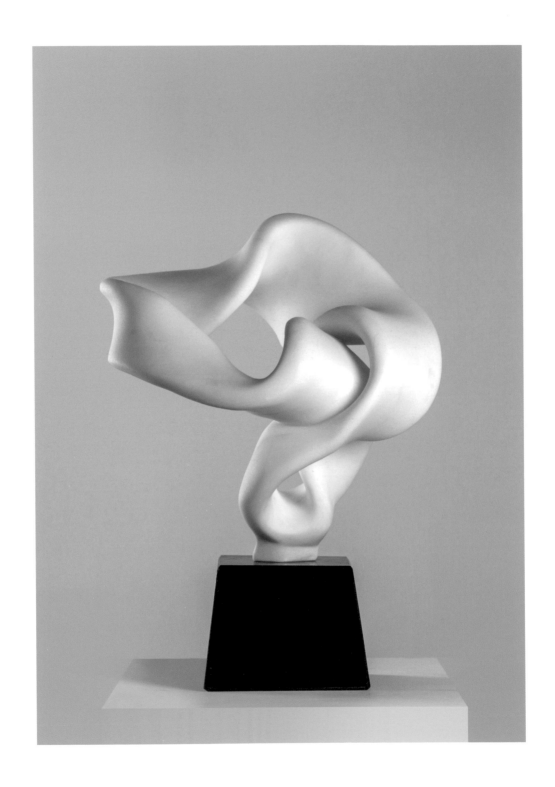

翱翔 *Hover* / 漢白玉 *White Marble* / *H36 x W36 x L38 cm 2011*

風起雲涌 *Blowing Clouds* / 漢白玉 *White Marble* / *H50 x W45 x L25 cm 2010*

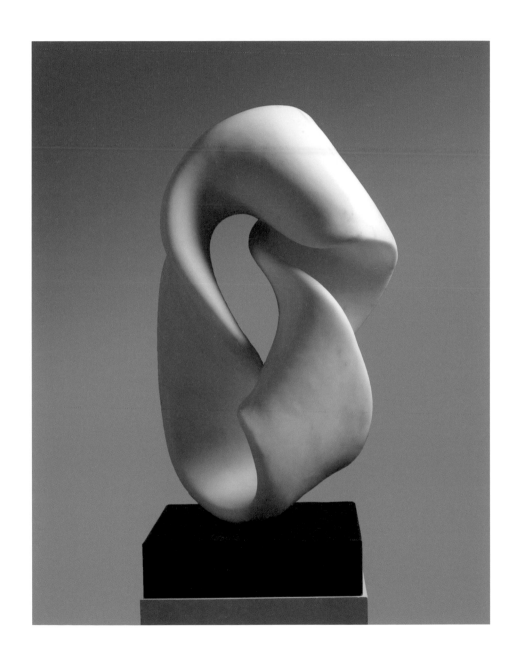

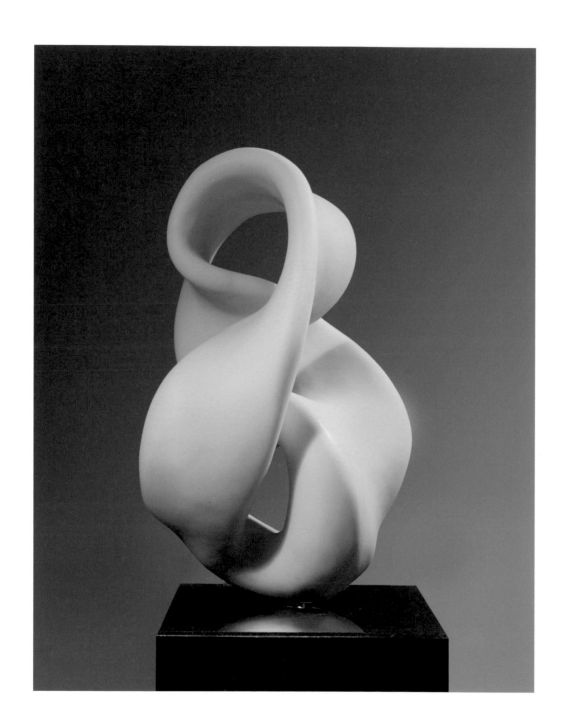

舞動人生 *Dancing of Life* / 漢白玉 *White Marble* / *H38 x W24 x L15 cm 2011*

翱翔 *Hover* / 黑花崗岩 *Black Granite* / *H67 x W59 x L45cm 2013*

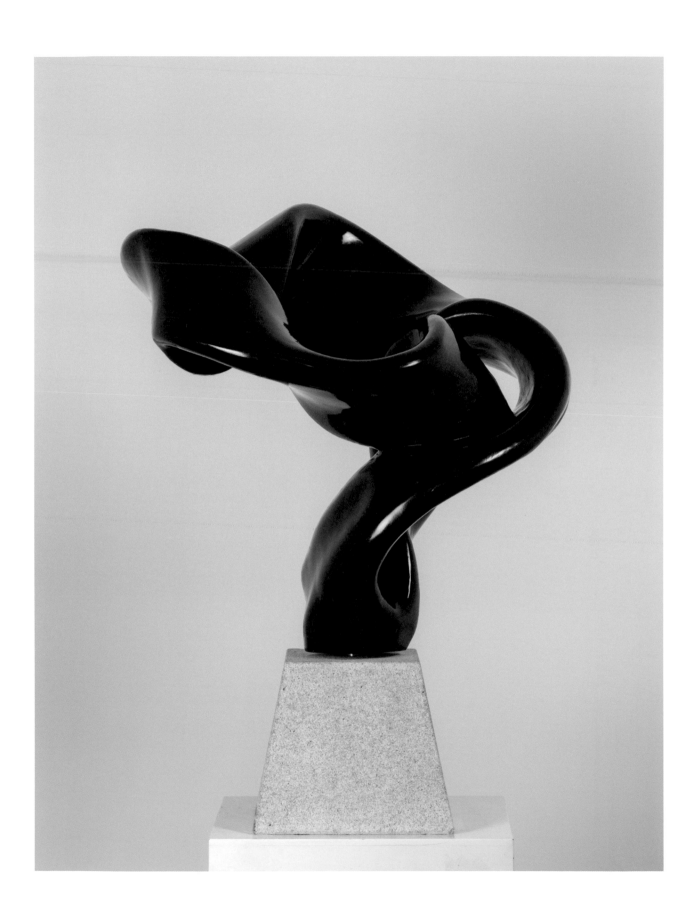

擁抱 *Embrace* / 黑花崗岩 *Black Granite*/ *H80 x W65 x L40 cm 2010*

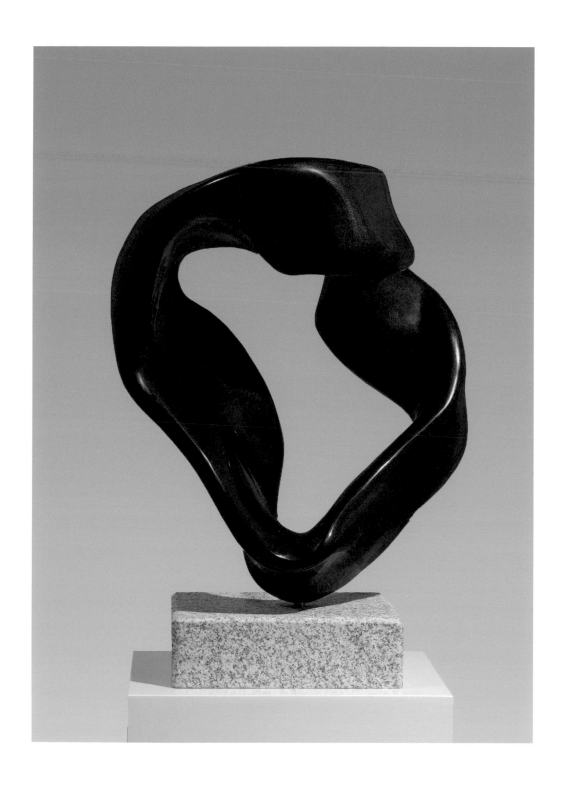

大象無形系列

Great Form without Shape Series

大象無形系列 2009-2020

大象無形系列作品，其發想來自老母親深植心中傳統文化故事中的神仙、關公、菩薩，他試圖藉由純熟的傳統工藝石雕技術，將久存心中的傳統文化故事主角及精髓，溶入個人的生活歷煉及禪學精神，以現代的技巧、造形重新詮釋。他將傳統文化故事與傳統工藝技術的斷層，賦予傳承與連接的意涵，即亨利羅素所稱的將古老轉化為現代。從現代藝術的表現手法來看，許東榮如今已由全抽象走向半具象，此種抽象中的具象，對他來說，抽象只是表像的手段。這也正是他作品的獨特表現，以及與其他台灣當代雕塑家相異之處。

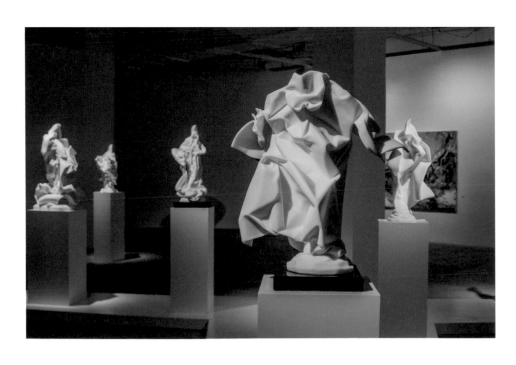

Great Form without Shape 2009-2020

Great Form without Shape series is actually inspired by traditional folk stories of Guan Gong, Bodhisattva and other immortals deeply embedded in his mother's memories. The artist tries to deconstruct main characters and essences of those stories with modern stone carving technologies, skills and forms, and reinterpret them based on his personal life experiences and perception of Zen Buddhism

He has carried on the heritage of the once discontinued traditional culture consisted of folk stories, old craftsmanship and artistry, and regenerated ancient culture with modernity like Henri Rousseau did. From the perspective of modern art techniques, Tung Lung Hsu has now moved from full abstraction to semi abstraction. For him, abstraction is only a means of representation, which distinguishes him and his works from other contemporary sculptors and sculptures in Taiwan.

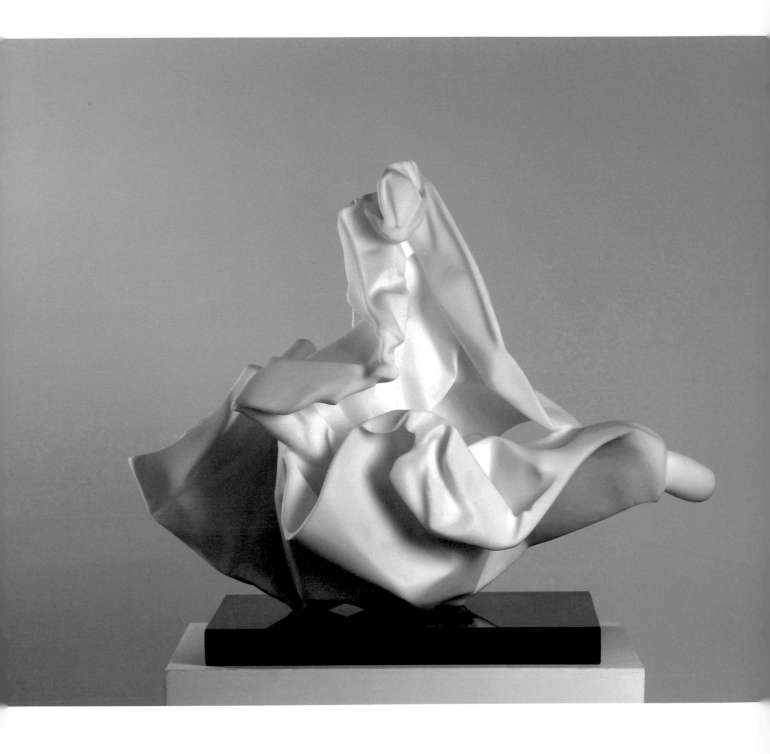

八仙過海 *The Immortal crossing the sea* / 漢白玉 *White Marble/ H75 x W25 x L33 cm 2013*

禪坐 *Meditation* / 漢白玉 *White Marble* / *H88xW60xL37cm 2015*

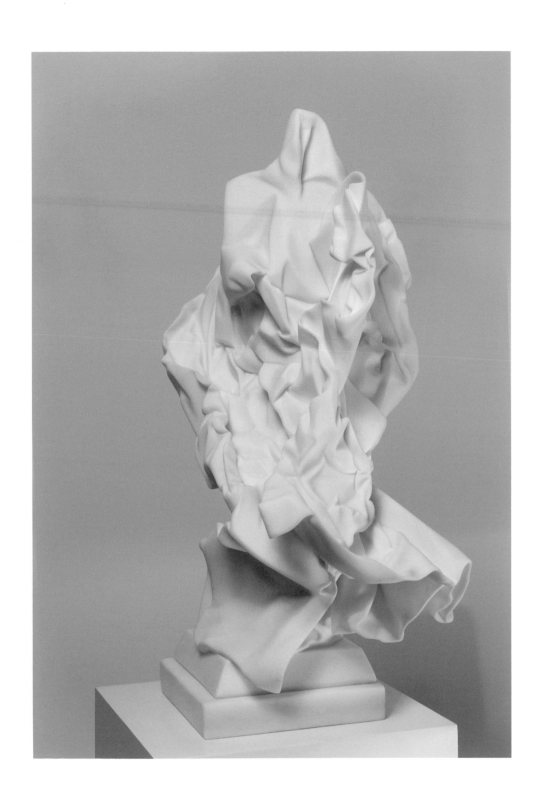

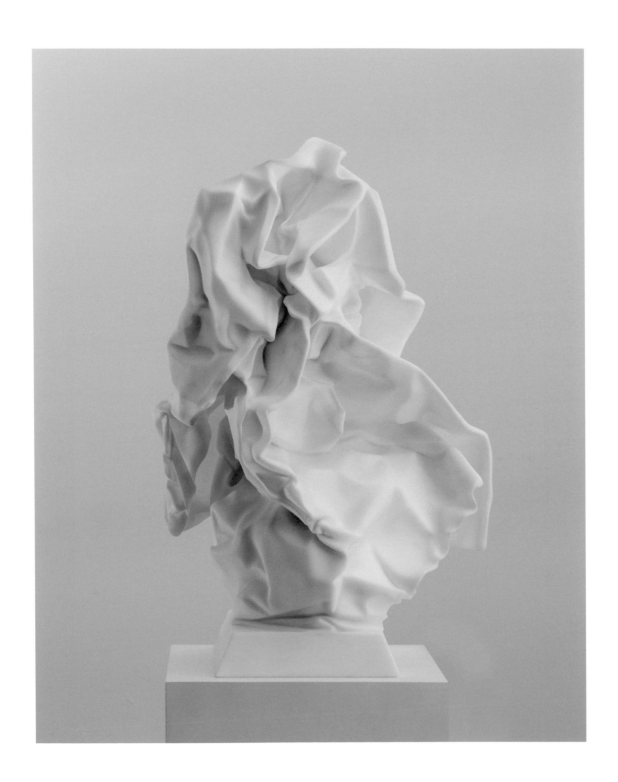

智者 *Sage* / 漢白玉 *White Marble* / *H80 x W52 x L40 cm 2014*

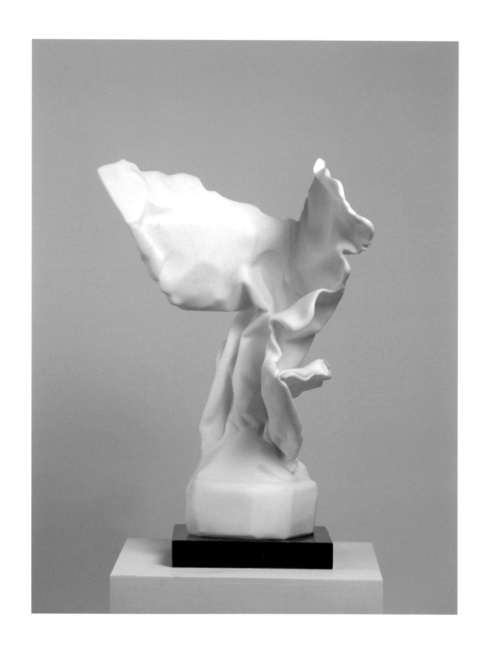

飛天 *Flying Apsaras* / 漢白玉 *White Marble / H75 x W52 x L45 cm 2013*

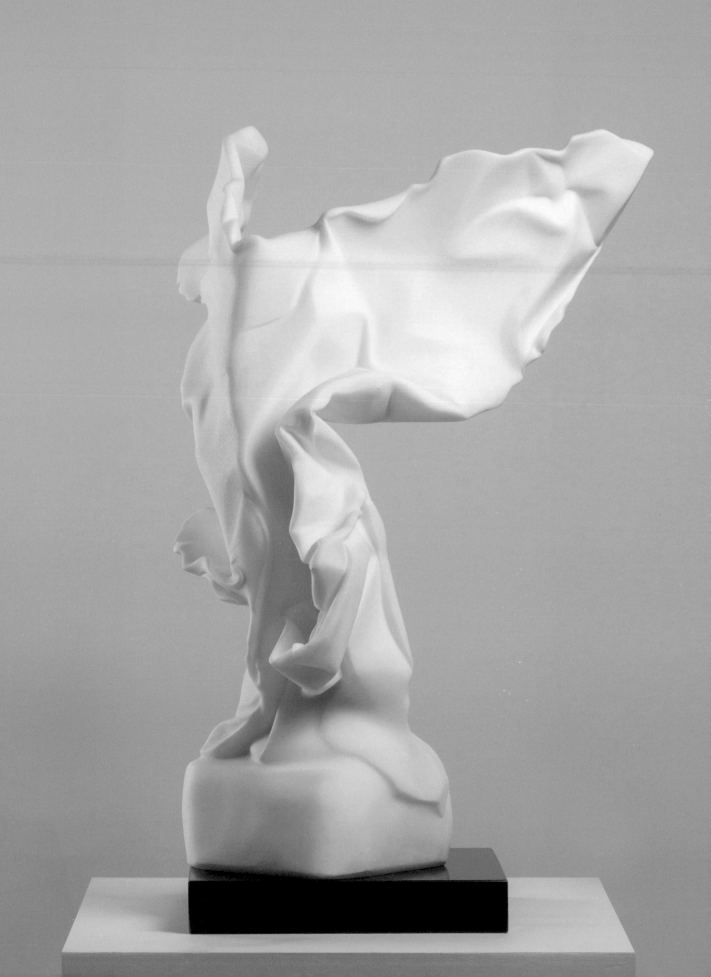

義薄擎天 *Great Loyalty* / 漢白玉 *White Marble* / *H75x W25 x L33 cm 2013*

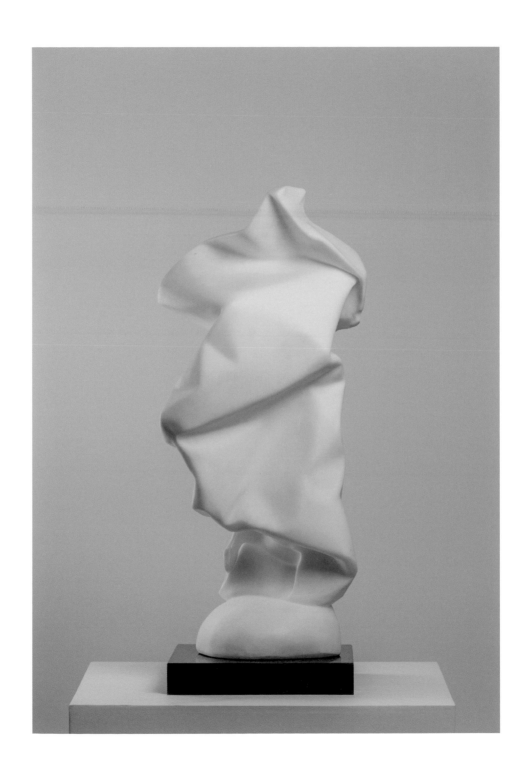

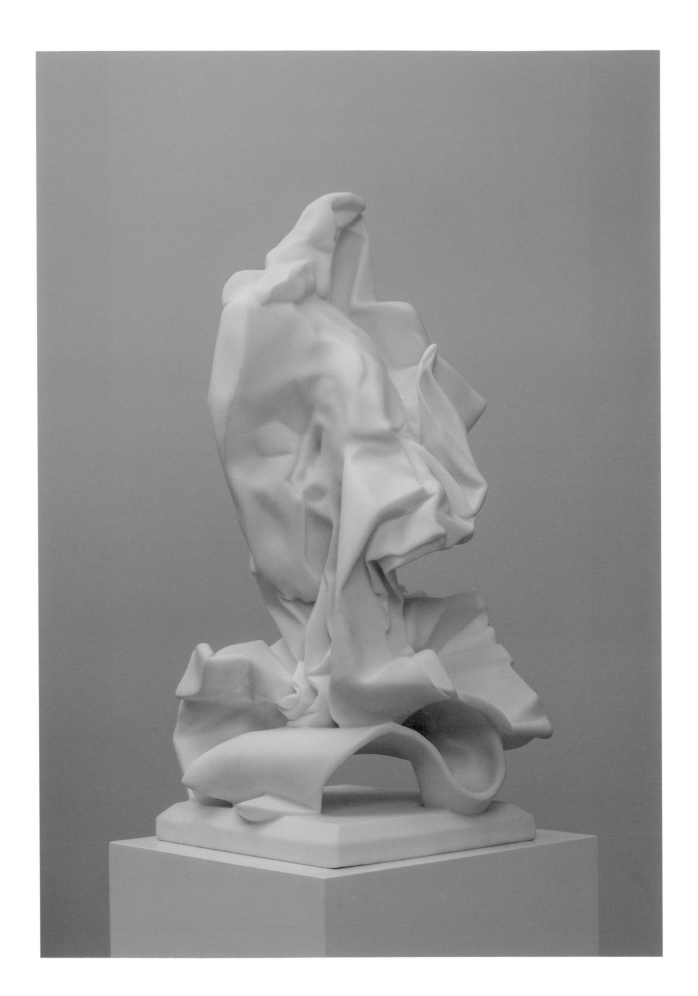

大士 *Overlord* / 漢白玉 *White Marble* / *H90 x W40 x L50 cm 2014*

尊者 *Respected/* 漢白玉 *White Marble / H75x W25 x L33 cm 2013*

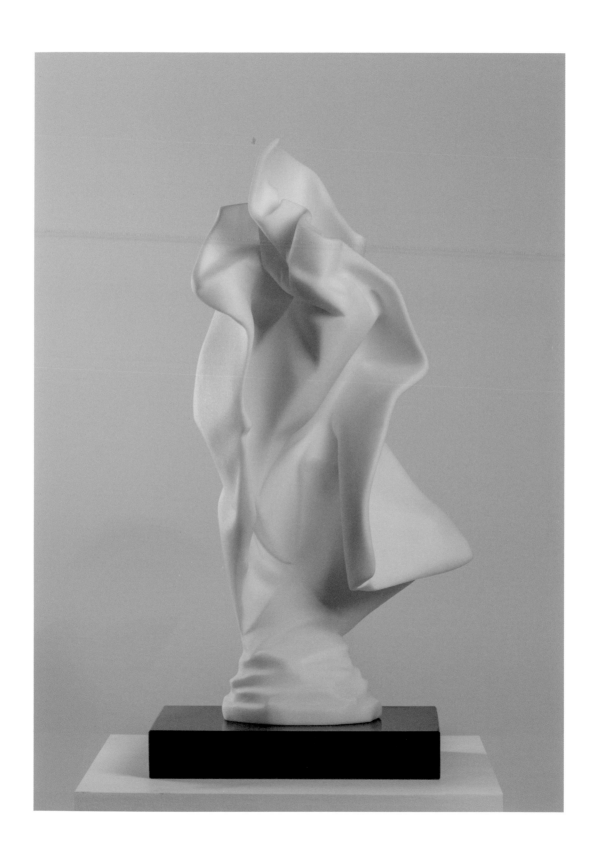

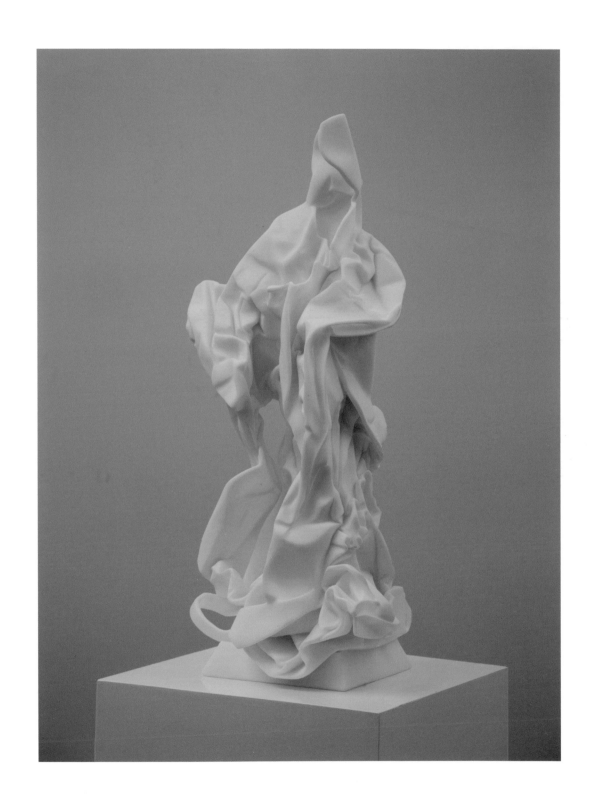

觀自在 *The Mercy Buddha* / 漢白玉 *White Marble /H75 x W30 x L35 cm 2015*

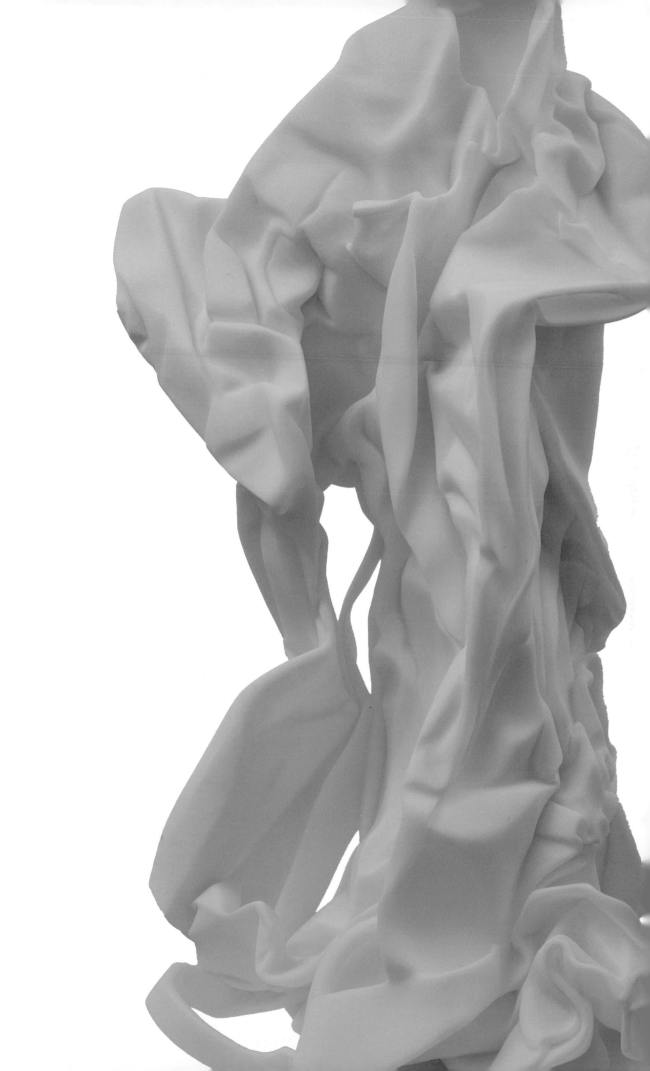

鯉躍龍門 *Soaring Leap* / 漢白玉 *White Marble* / *H77 x W40 x L30 cm 2016*

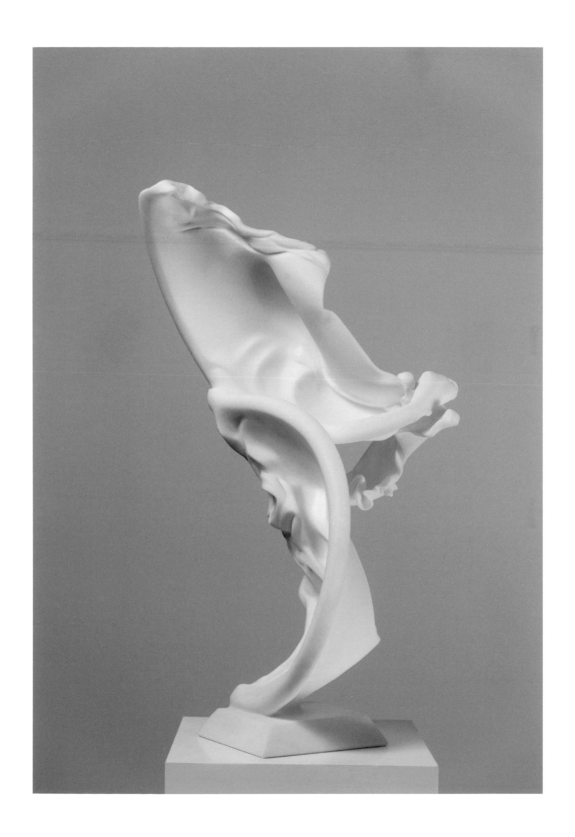

英雄 *Hero* / 漢白玉 *White Marble* / *H76 x W54 x L48 cm 2014*

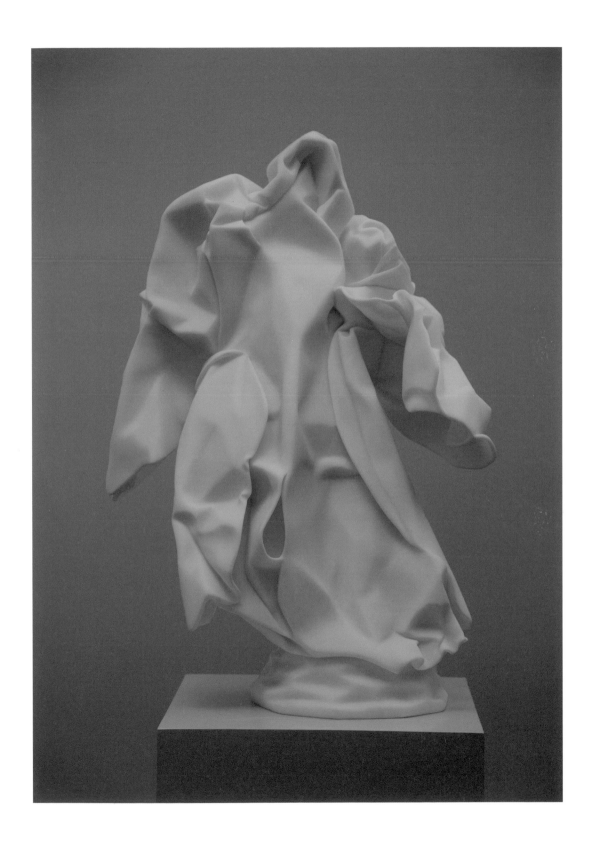

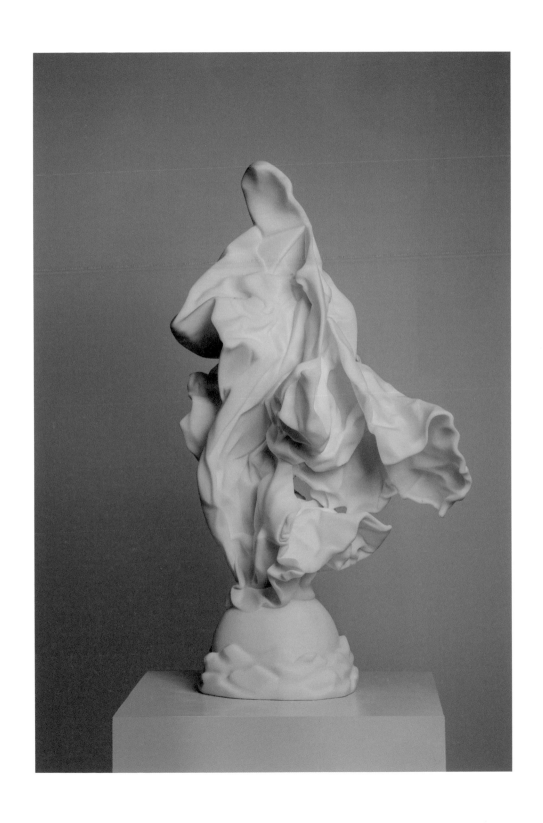

搖曳蓮華 *Graceful Lotus* / 漢白玉 *White Marble* / *H75 x W36 x L48 cm 2016*

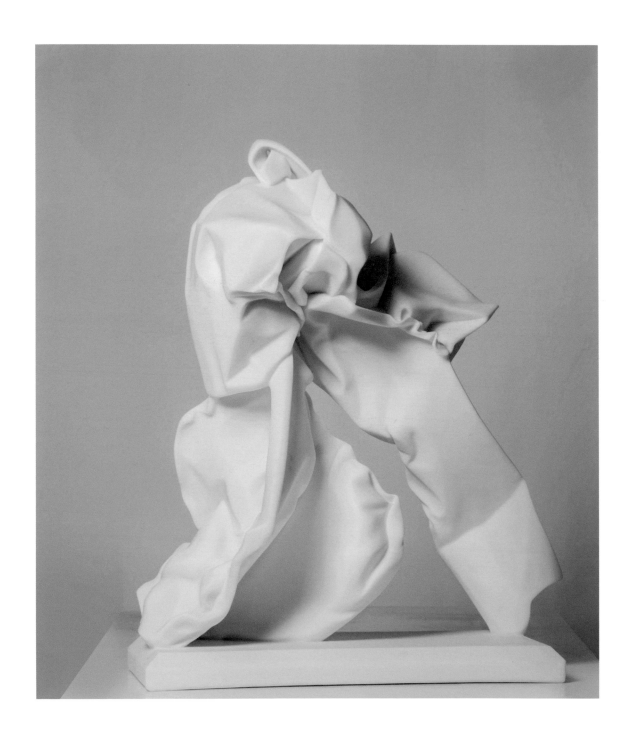

降龍伏虎 *Subdue the Dragon and Tame the Tiger* /漢白玉 *White Marble / H84 x W33 x L62 cm 2017*

自在蓮華 *Free Lotus* / 漢白玉 *White Marble* / *H75 x W35 x L45 cm 2017*

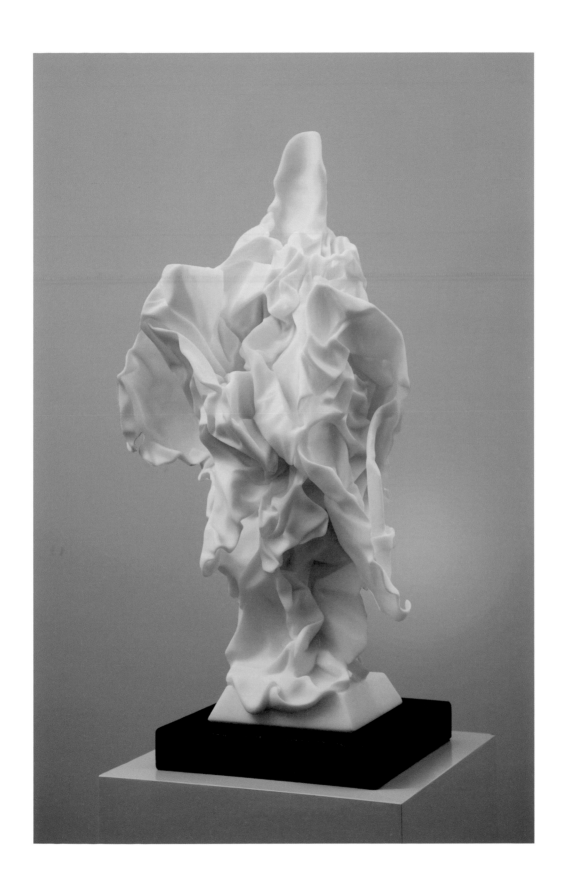

廉頗 *Lian Po* / 漢白玉 *White Marble* / *H72 x W30 x L35 cm 2017*
藺相如 *Lin Xiangru* / 漢白玉 *White Marble* / *H72 x W33 x L34 cm 2017*

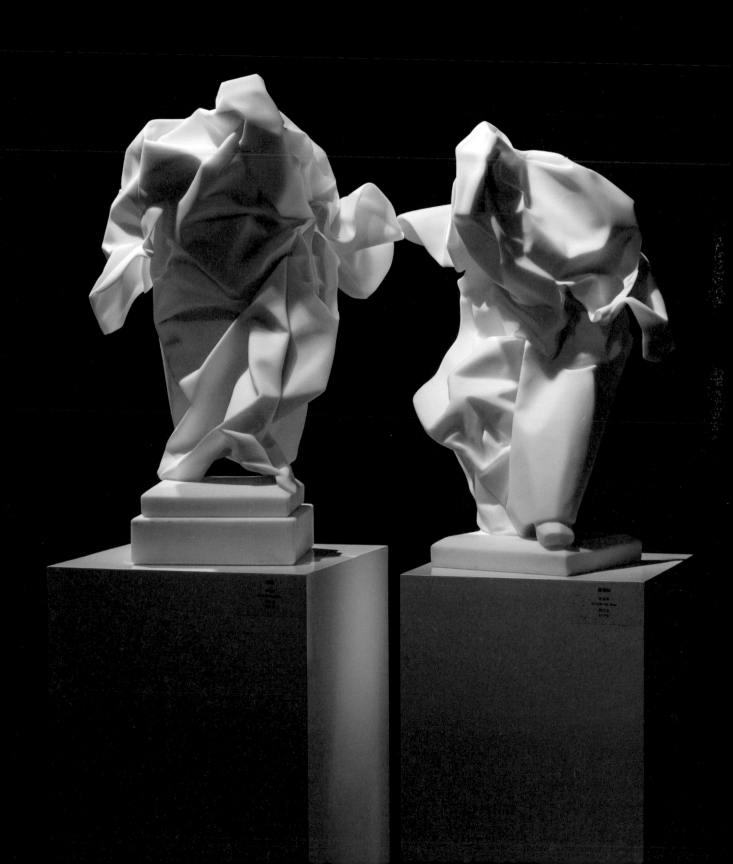

魁星 *Star of Wisdom* / 漢白玉 *White Marble* / *H72 x W32 x L63 cm 2016*

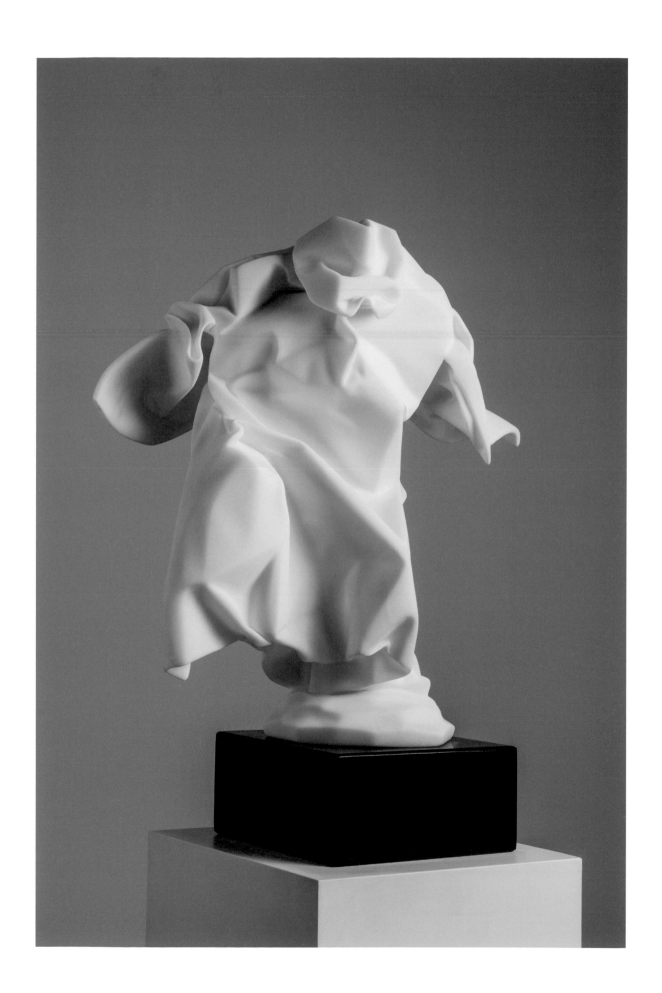

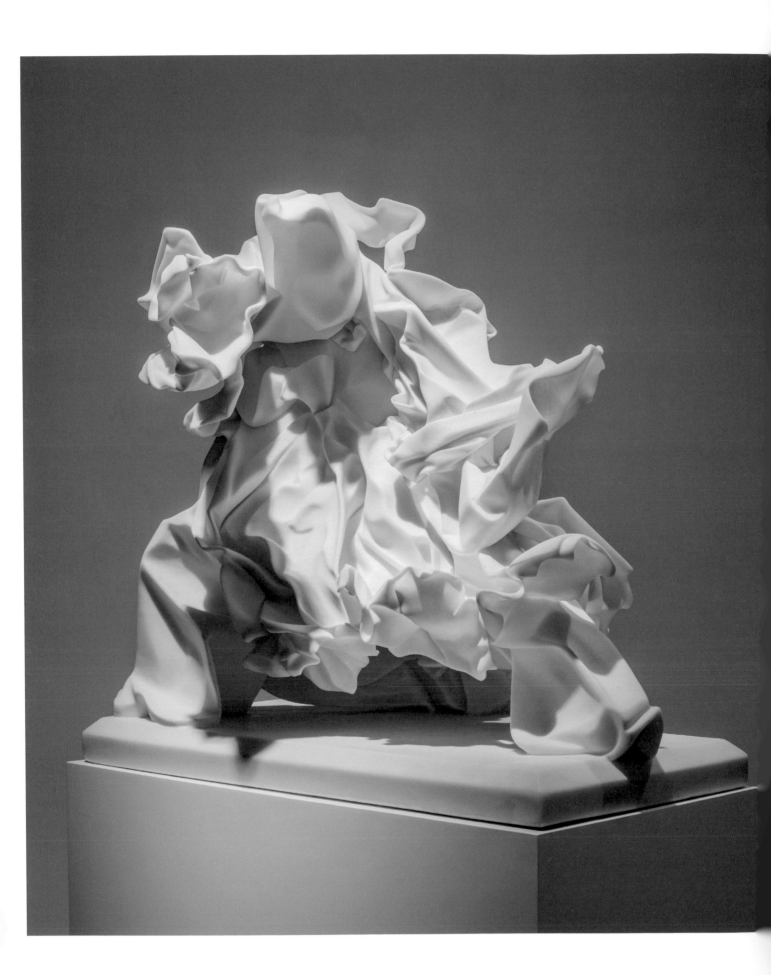

三太子 *Nalakuvara* / 漢白玉 *White Marble* / *H70 x W40 x L80 cm 2018*

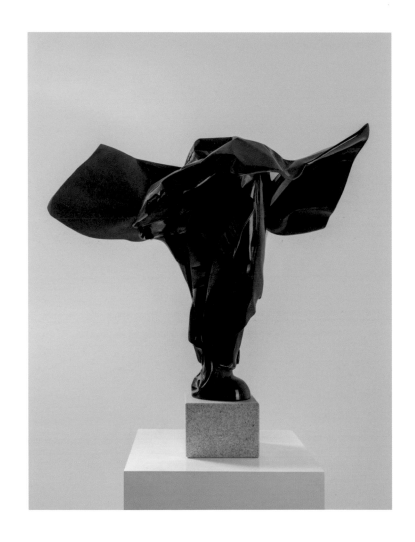

天女散花 *The heavenly maids scatter blossoms* / 黑花崗岩 *Black Granite* / *H100 x W70 x L107 cm 2018*

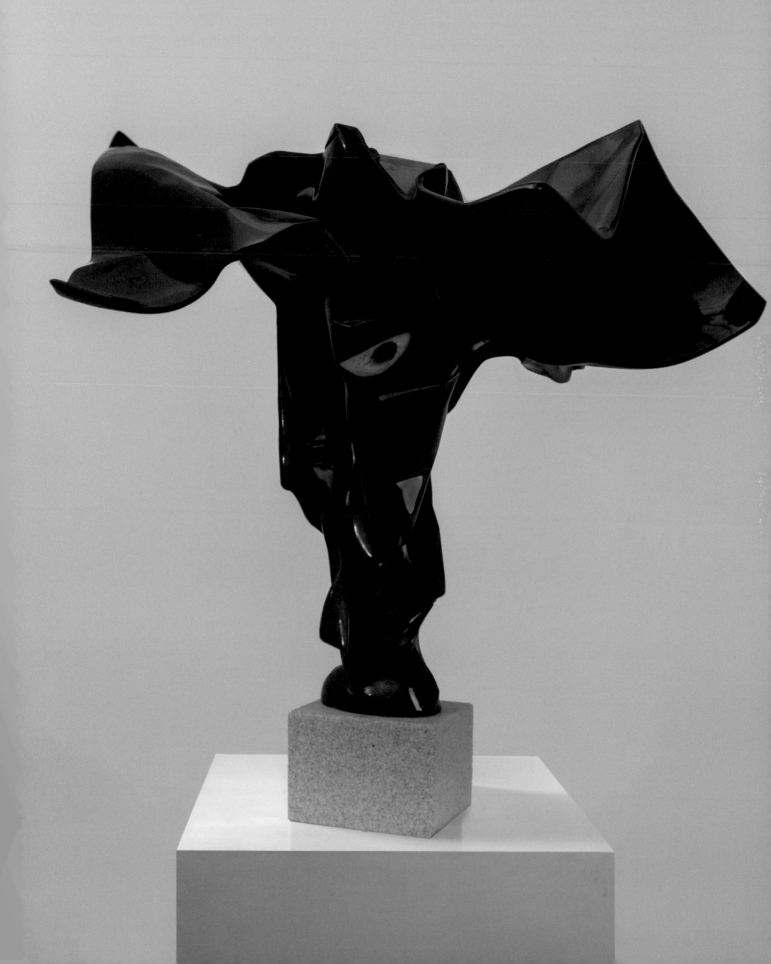

鯤 *KUN* / 黑花崗岩 *Black Granite* / *H105 x W52 x L45 cm 2019*

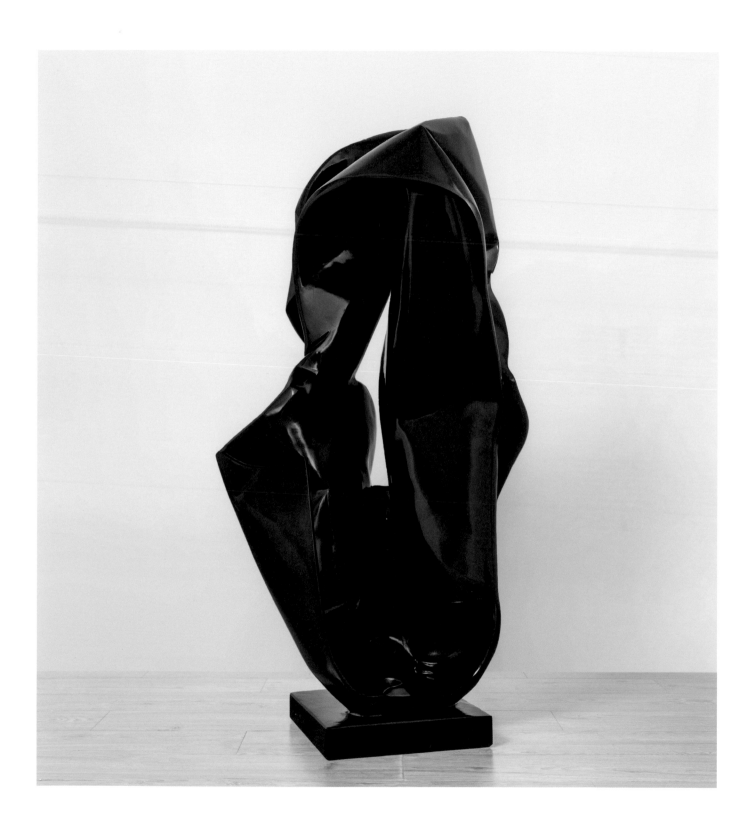

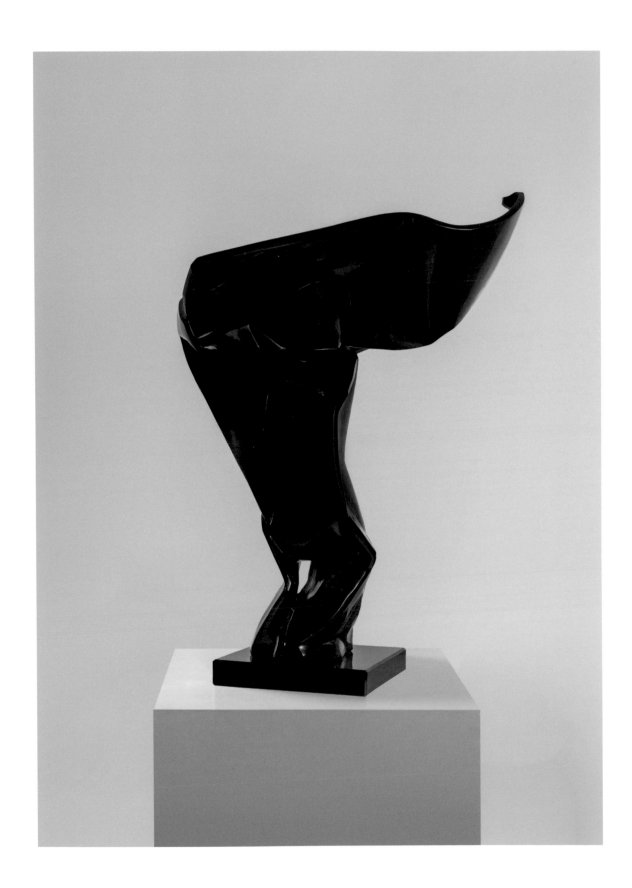

鵬 *PENG* / 黑花崗岩 *Black Granite* / *H95 x W50 x L80 cm 2019*

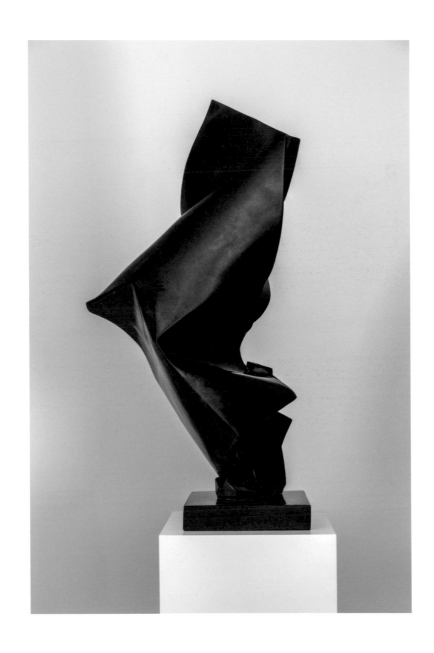

姿態 *Posture* / 黑花崗岩 *Black Granite* / *H115 x W41 x L50 cm 2019*

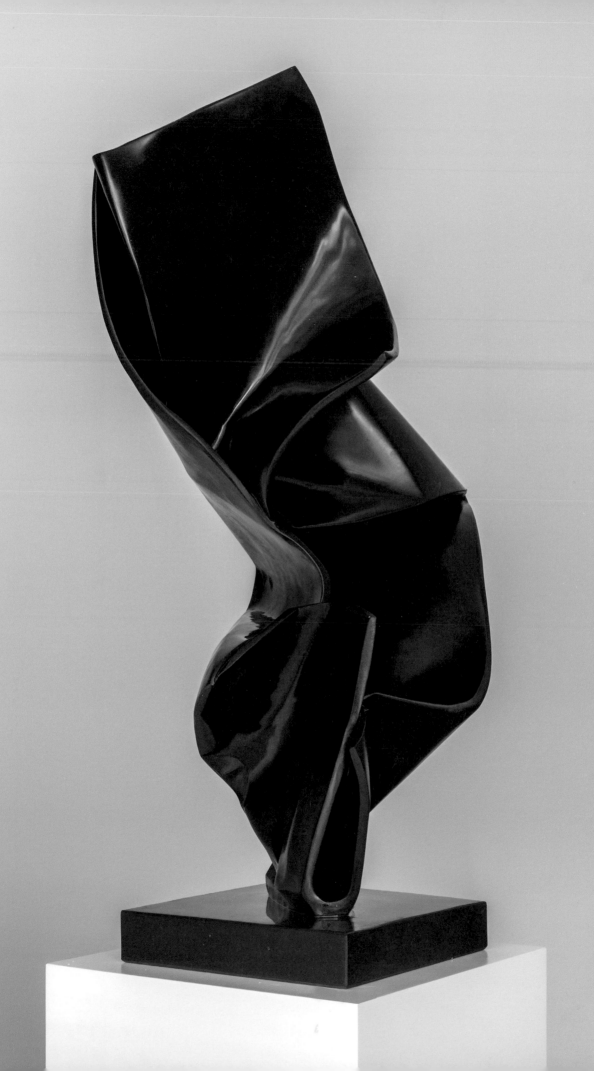

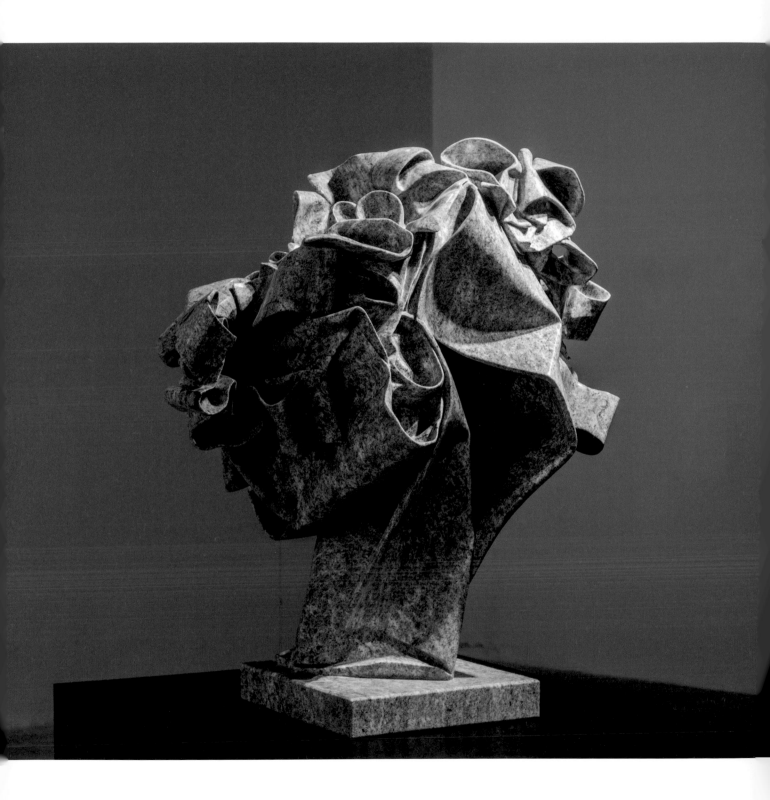

生命之樹 *Tree of Life* / 黑花岗岩 *Black Granite* / *H120 x W100 x L95 cm 2019*

美術館展覽

Art Museum Exhibition

TUNG LUNG HSU
Solo Exhibition at
National Art Museum of China

中國美術館
許東榮個展

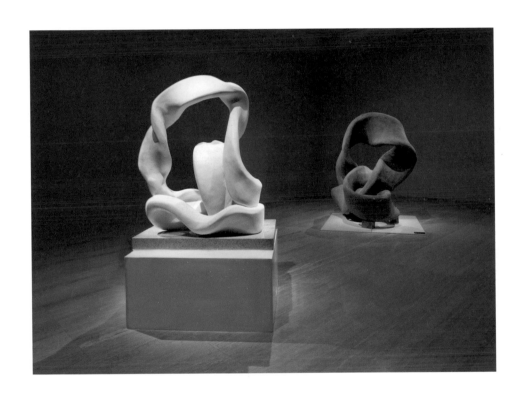

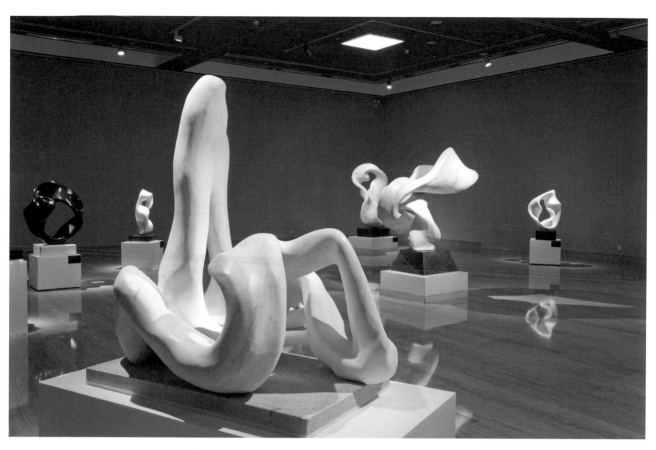

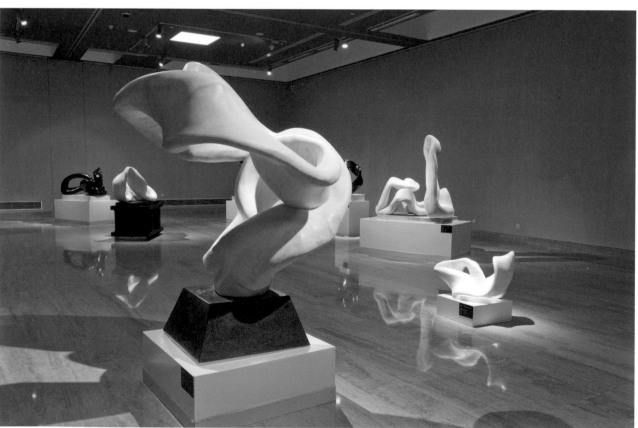

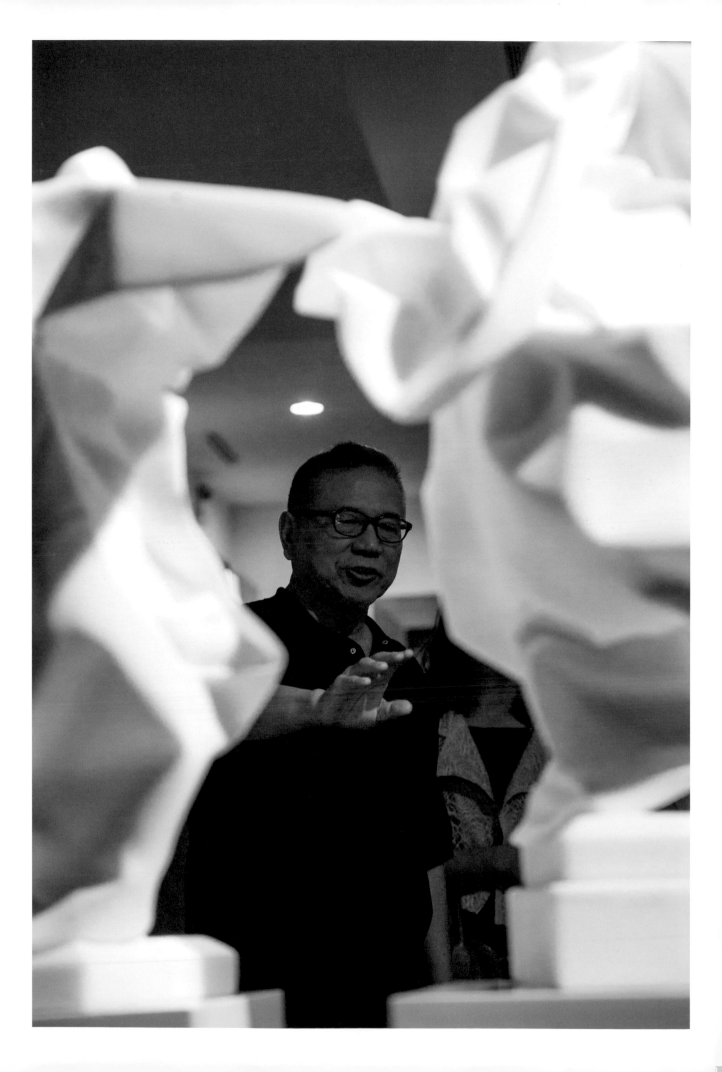

TUNG LUNG HSU

Solo Exhibition at
Guangdong Museum of Art

廣東美術館
許東榮個展 - 生命雕畫

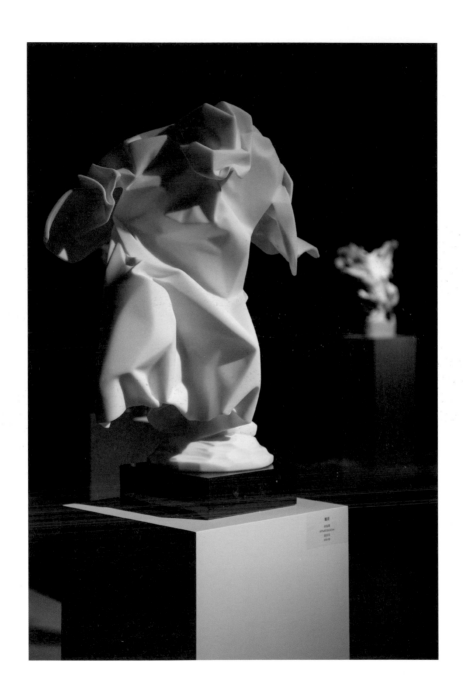

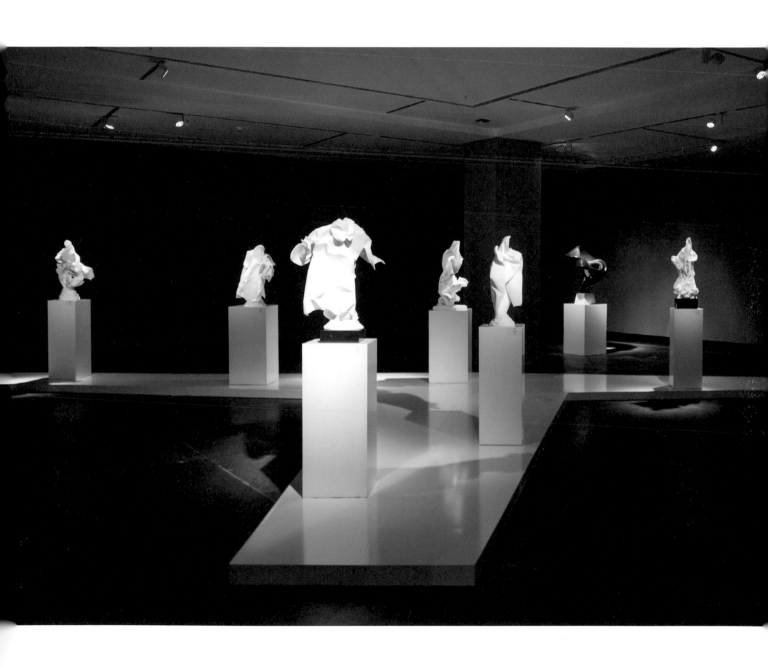

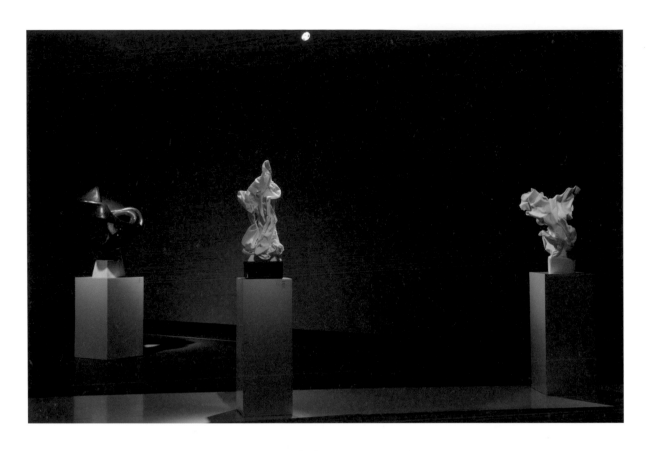

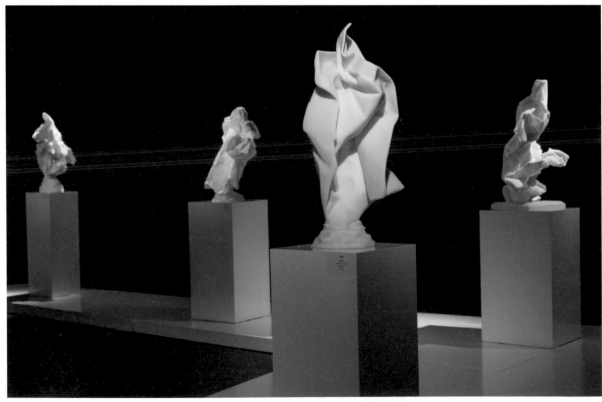

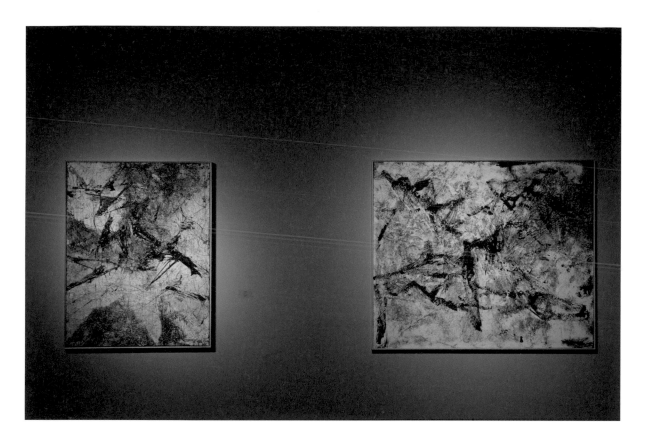

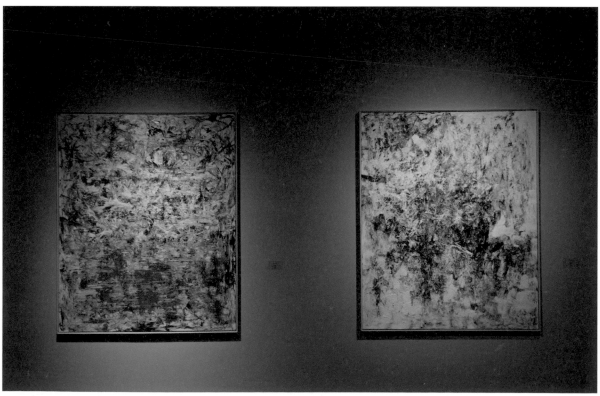

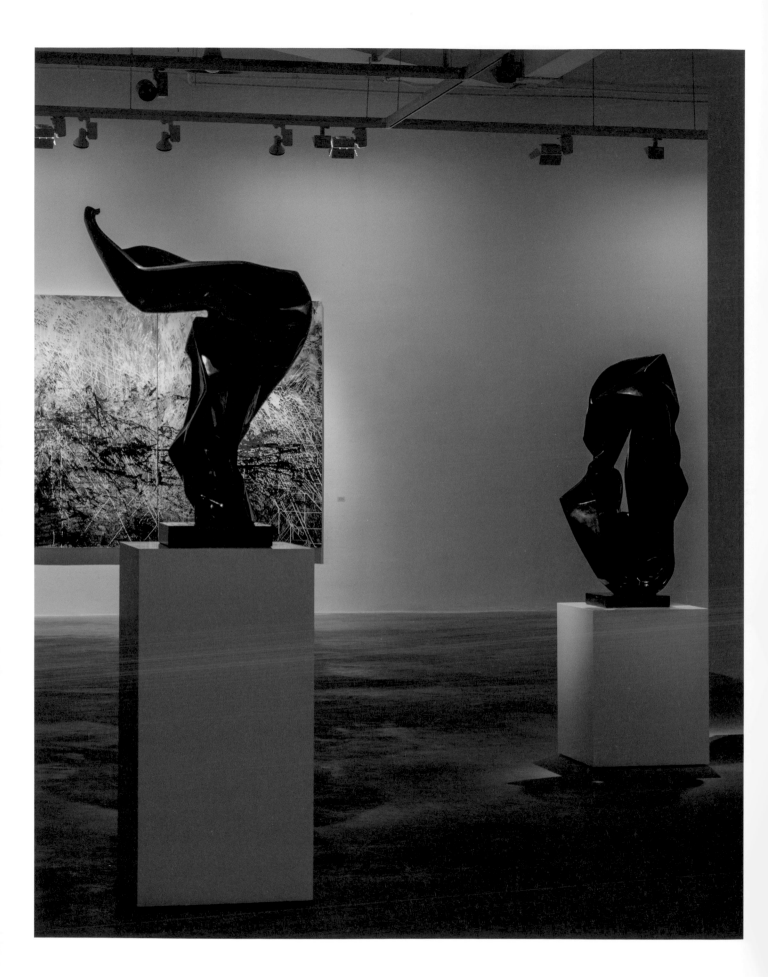

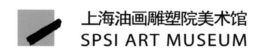

SPSI ART MUSEUM

TUNG LUNG HSU
Solo Exhibition at
SPSI Art Museum

上海油畫雕塑院美術館
許東榮個展 - 鯤

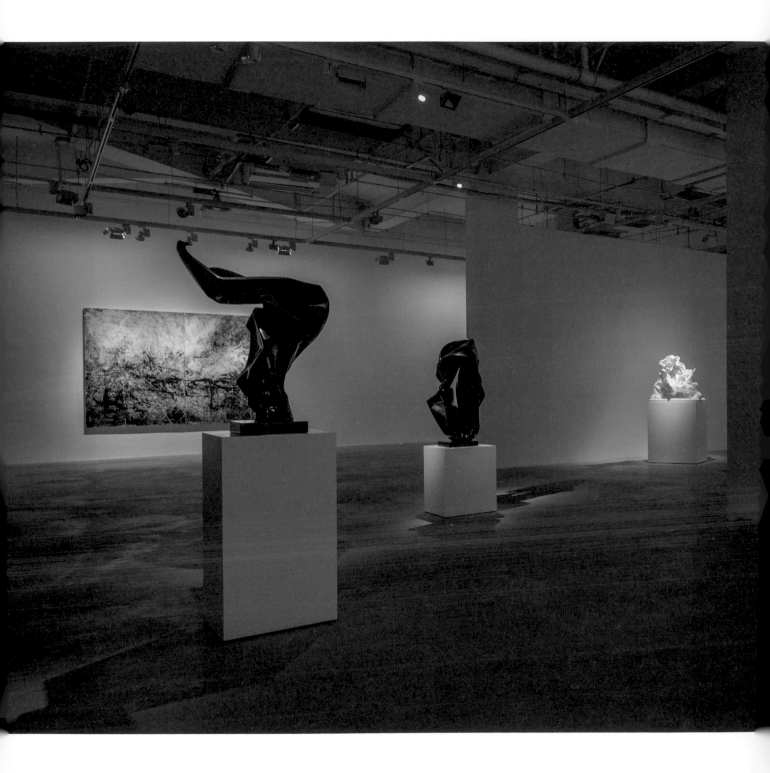

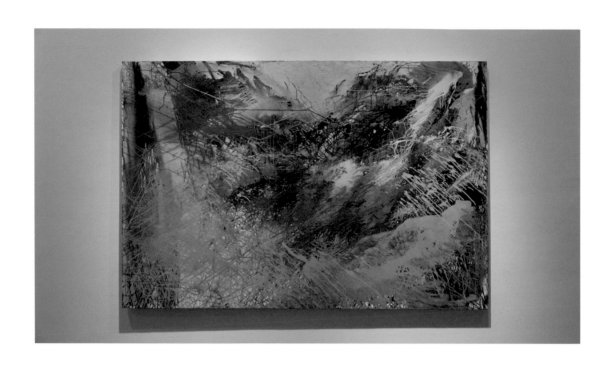

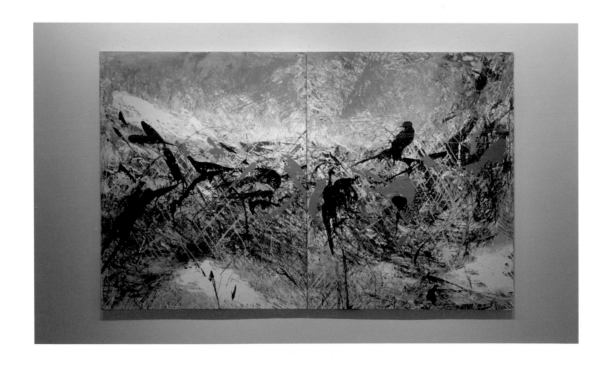

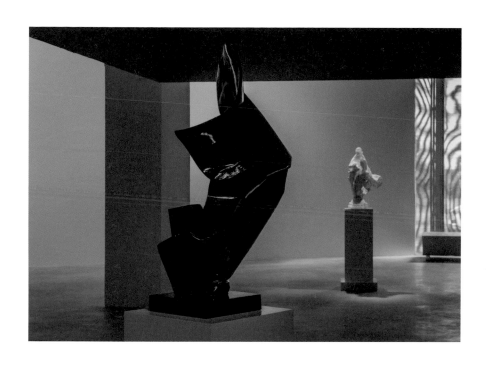

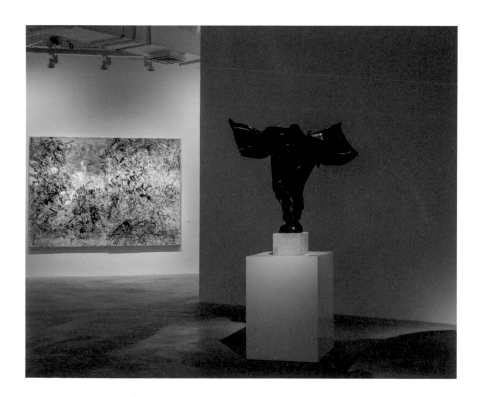

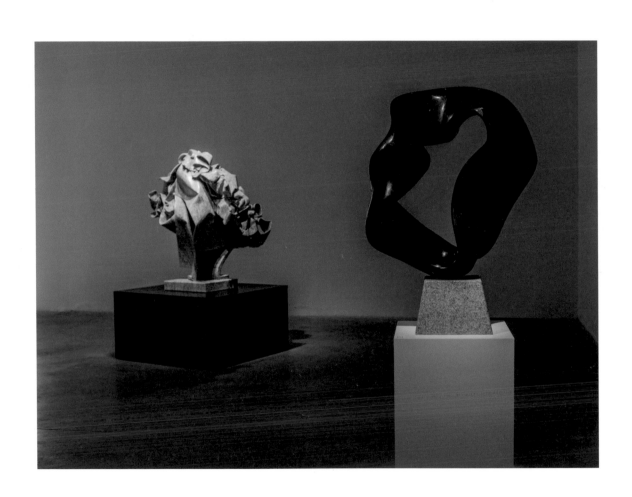

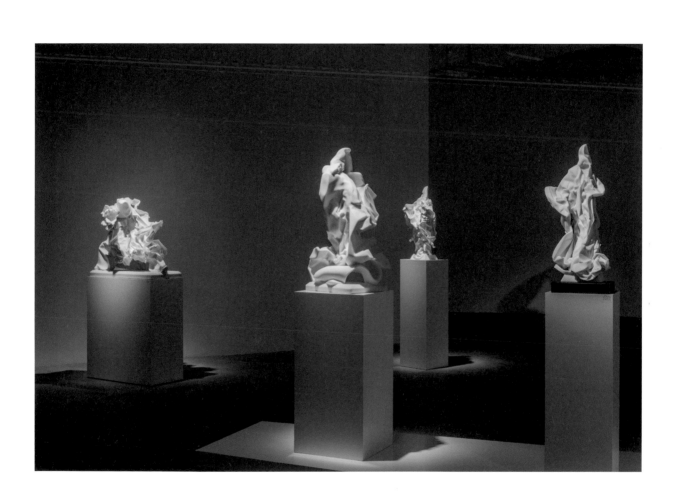

景觀雕塑作品

Landscape Sculpture

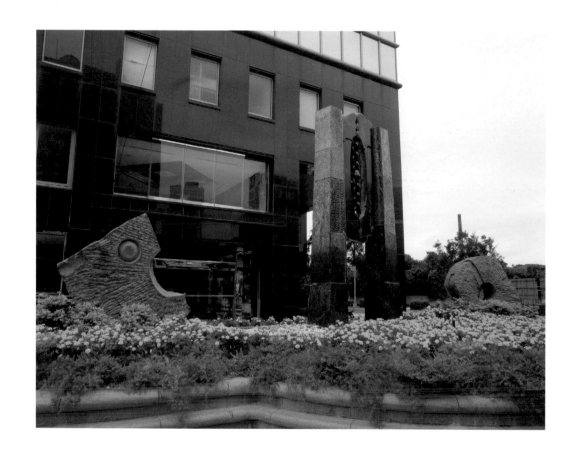

1992 藝術家許東榮雕刻陳列於台灣台北金山南路金融中心
1992 Public Display of Tung Lung Hsu's works at Taipei Financial Building on
Chun-Hsiao East Road Section 5

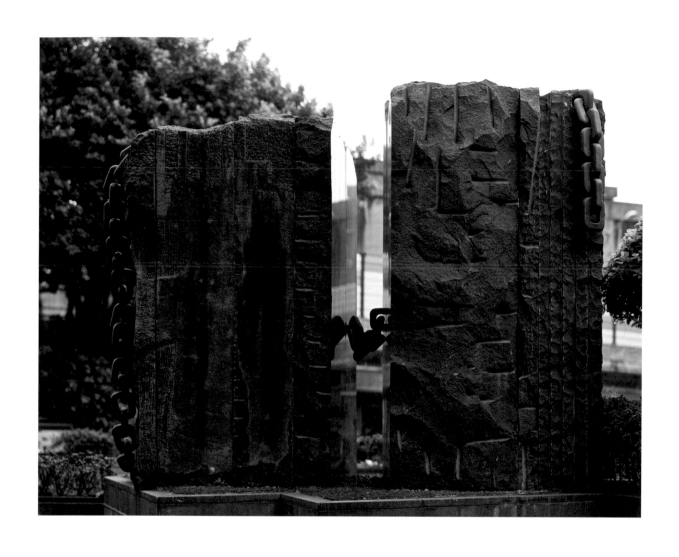

1997 藝術家許東榮雕刻陳列於台灣台北金山南路金融中心
1997 Public Display of Tung Lung Hsu's works at Taipei Financial Building on
Chun-Hsiao East Road Section 5

2012 藝術家許東榮雕刻陳列於台灣新竹閑谷活動中心
2012 Public Display at HsinZhu Xiangu Activity center in Taiwan

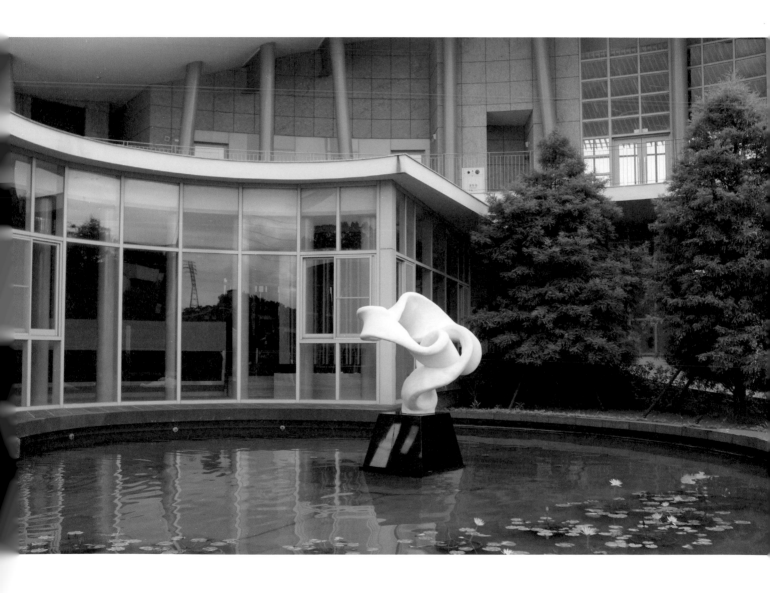

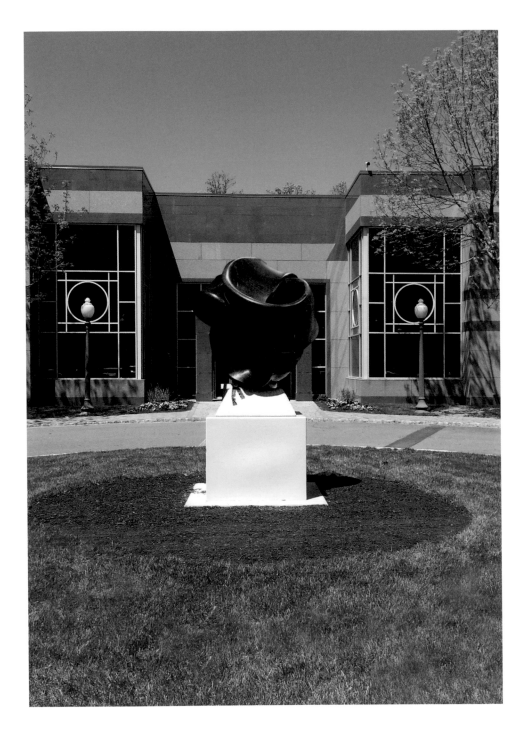

2012 雕刻作品＜黑玫瑰＞陳列於美國新澤西 *Fedway Associate*
2012 Sculpture "Black Rose" Displayed at New Jersey Fedway Associate

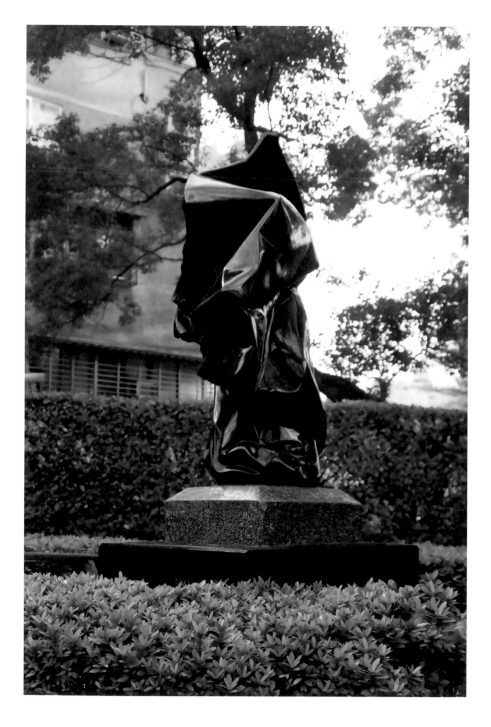

2013 藝術家許東榮雕刻陳列於台灣台北金山南路金融中心
2013 Public Display of Tung Lung Hsu's works at Taipei Financial Building on
Chun-Hsiao East Road Section 5

2019 雕刻作品 < 雲彩飛舞 > 陈列于静安雕塑公園

2019 Sculpture "Clouds" Displayed at Jingan Sculpture Park

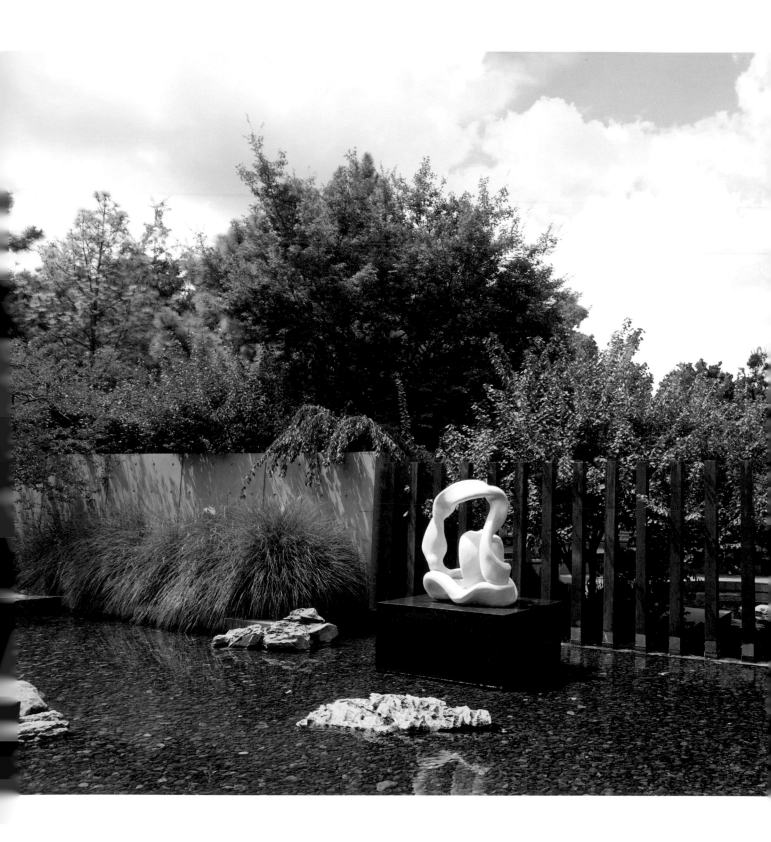

簡歷

Biography

許東榮 *Tung Lung Hsu*

　　1947 年，許東榮在台灣屏東出生，決定當藝術家，對許東榮來說，就像自然而然，骨子裡流淌的想法。沒有非要成就什麼，沒有非要成功，只是因為一份喜歡、一份執著，就這樣，40 多年來刻畫了他的一生。從廟宇文化得來的養分，玉雕工廠、陶瓷工廠的訓練，再到學院的美術訓練。到後來，不斷打破自己的習慣、打破固化的創作形式，去掉了熟悉的繪畫工具，利用飯勺、菜刀畫畫，或是不雕不塑，摔了泥巴再組合出的雕塑形體。

　　這一路走到了今天，他自己說，無論繪畫或是雕塑，現在是兩者完全合而為一。繪畫是雕塑空間的再延續，雕塑是繪畫的再創造。

許 東 榮

1947　生於台灣屏東

教育背景

1967　台灣國立師範大學美術系畢業

個展

2019　「鯤」—許東榮個展，上海油畫雕塑院美術館，上海

2018　「拼圖」—許東榮個展，八大畫廊，上海

2017　「生命雕畫」—許東榮個展，廣東美術館，廣州

2014　「大象無形」-- 許東榮新作北京 - 上海巡回展，山藝術 - 北京林正藝術中心，北京 /
　　　八大畫廊，上海

2014　ArtStage 新加坡藝術博覽會，新加坡，

2013　Art021 當代藝術博覽會，上海

2011　「抽象空間」，新藝術博覽會，台北

2011　「時空的軌跡」—許東榮個展，中國美術館，北京

2010　台北藝術博覽會，台北

2007　第四屆中國國際畫廊博覽會，北京

2005　油畫雕刻個展，台北市畫廊博覽會，台北

2003　油畫雕刻個展，台北市畫廊博覽會，台北

1998　雕刻個展，台灣中歷元智大學，台北

1996　油畫雕刻展，台南市立文化中心藝廊，台南

1995　雕塑個展，八大畫廊油畫，台北

1986　台北福華沙龍「許東榮第二次現代玉雕展」，台北

1985　日本 NHK 拍攝故宮之旅介紹現代玉雕代表藝術家
　　　台灣公共電視製作「靈巧的手、雕玉的手」專輯
　　　台北市立美術館個人小型玉雕展，台北

1983　阿波羅畫廊個人現代玉雕展，台北

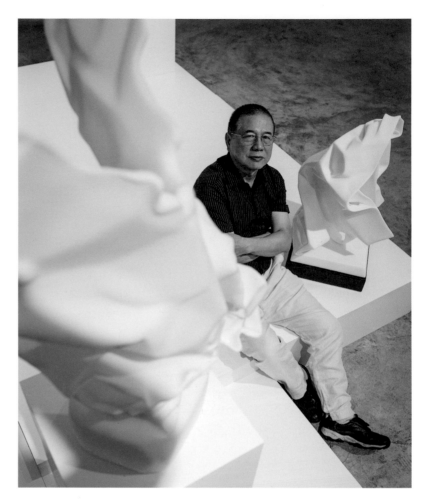

About *Tung Lung Hsu*

In 1947, Tung Lung Hsu was born in Pingtung, Taiwan For Tung Lung Hsu, the idea of becoming an artist was as natural as something inborn in his blood. He has dedicated over 40 years in that, not for success or to accomplish anything, but for love, which portrays his whole life.

He assimilates art nutrients from the temple culture. He gets training in both jade carving factory, ceramic factory and academy of fine arts. He constantly breaks his own habits and rigid patterns of creation. He abandons painting tools that he is familiar with, using rice spoon, kitchen knife instead. He even does sculptures without sculpting or carving, just slaming mud lumps into shapes and combining them. To this day, to use his own words, painting and sculpture have fully blended with each other and become one for him. Painting is the extention of sculpture in space, and sculpture is the further creation of painting.

Tung Lung Hsu (b. 1947, Taiwan)

Education

1976 Taiwan National Normal University, Master of Fine Arts

Solo Exhibition

2019 *Kun*-Tung Lung Hsu Solo Exhibition，Shanghai Oil Painting & Sculpture Institute Art Museum，Shanghai

2018 *Puzzle of lifetime* － Tung Lung Hsu Solo Exhibition，Pata Gallery, Shanghai,

2017 *Spirit Carved Painted* － Tung Lung Hsu Solo Exhibition, Art Museum of Guangdong, Guangzhou

2014 *New Works of Tung Lung Hsu Solo Exhibition Tour 2014*，Mountain Art Foundation + Frank Lin Art Center，Beijing/Pata Gallery，Shanghai

2014 Art Stage Singapore Fair，Singapore

2013 ART021 Shanghai Contemporary Art Fair, Shanghai

2011 *Abstraction In Space*, ART Revolution, Taipei

2011 *A Trail of the Time-Tung Lung Hsu Solo Exhibition*，National Art Museum of China, Beijing

2010 Art Taipei 2010, Taipei

2007 The 4th China International Gallery Exposition 2007 (CIGE), Beijing

2005 Solo sculpture exhibition, Taipei Gallery Exposition, Taipei

2003 Solo sculpture exhibition, Taipei Gallery Exposition, Taipei

1998 Solo sculpture exhibition, Yuan Ze University, Zhongli

1996 Oil painting and sculpture exhibition, Tainan City Culture Center Gallery, Tainan

1995 Oil painting and sculpture Solo exhibition, Pata Gallery, Taipei

1986 HSU TUNG LUNG 2nd Modern Jade Sculpture Exhibition, Taipei Howard Salon, Taipei

1985 Individual Jade Sculpture Exhibition, Taipei City Fine arts Museum, Taipei

1983 Individual exhibition of modern jade sculpture, Apollo Gallery Taipei, Taipei

國家圖書館出版品預行編目（CIP）資料

鯤：許東榮作品集 / 許詠涵作. --
初版. -- 臺北市：藝術家，2019.12
136面；21×28.5公分
ISBN 978-986-282-244-9(精裝)

1.雕塑 2.作品集

930 108022435

許東榮
Tung Lung Hsu

發 行 人｜許東榮
作　 者｜許詠涵
英文翻譯｜黃瑩
資料編輯｜林慧萍
美術設計｜顧曉妮 何承翰
文稿口訪｜林慧萍
攝　 影｜何承翰
出 版 者｜藝術家出版社
　　　　｜地址：臺北市金山南路（藝術家路）二段 165 號 6 樓
　　　　｜電話：02-2388-6715,2388-6716
　　　　｜傳真：02-2396-5708
　　　　｜郵政劃撥：50035145 藝術家出版社帳戶

編輯製作｜許詠涵

總 經 銷｜時報文化出版企業股份有限公司
倉　 庫｜桃園市龜山區萬壽路二段 351 號
電　 話｜（02）2306-6842

製版印刷｜欣佑彩色製版印刷股份有限公司

初　 版｜2019 年 12 月
定　 價｜新臺幣 700 元

ISBN 978-986-282-244-9

八大畫廊 | 上海 普陀區莫干山路 50 號 M50 藝術區 4 號樓 A1 層
Tel　　　 +86 21 32270361
Email　　 pata@patagallery.org
官方網址　www.patagallery.com

Pata Gallery | Shanghai　No.50 Moganshan Rd, 4Rm A1
Tel　　　 +86 21 32270361
Email　　 pata@patagallery.org
Website　 www.patagallery.com

PATA GALLERY